IMAGES
of America

TACOMA'S
PROCTOR
DISTRICT

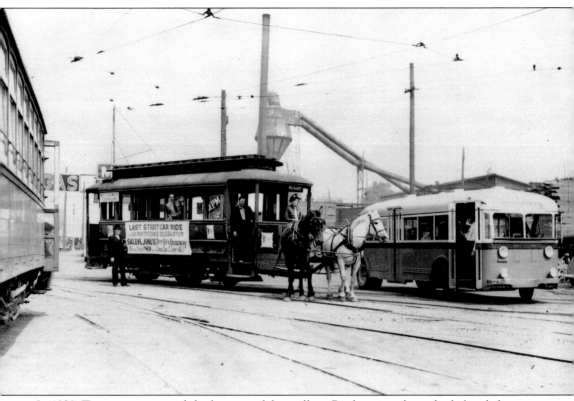

In 1938, Tacomans witnessed the last run of the trolleys. By that time, buses had already begun their routes through the city following those initially created by the streetcars. The first Proctor residents would have ridden on a coach like the one seen in the center of this view. Today bus riders using route No. 11 can follow the tracks and the horses that once wandered through the neighborhoods of the city.

ON THE COVER: Tacoma's Proctor District was the product of Allen C. Mason's Point Defiance streetcar line. By 1890, trolleys were running through the North End forests, and every turn in the route ultimately became a neighborhood commercial center. The intersection at North Twenty-sixth and Proctor Streets was such a place, one where businesses and houses mushroomed over time to create a streetcar suburb within the city of Tacoma.

IMAGES *of America*

TACOMA'S
PROCTOR
DISTRICT

Caroline Gallacci and Bill Evans

ARCADIA
PUBLISHING

Published by Arcadia Publishing
Charleston, South Carolina

Printed in the United States of America

Library of Congress Catalog Card Number: 2007928540

For all general information contact Arcadia Publishing at:
Telephone 843-853-2070
Fax 843-853-0044
E-mail sales@arcadiapublishing.com
For customer service and orders:
Toll-Free 1-888-313-2665

Visit us on the Internet at www.arcadiapublishing.com

*To Brian Kamens, along with the entire crew at the
Tacoma Public Library Northwest Room.*

CONTENTS

ACKNOWLEDGMENTS

The City of Tacoma might be unique in having three historians on its governing council. Interesting, too, is that each member has some association with the history of the Proctor District. Mayor Bill Baarsma taught at the University of Puget Sound. Council member Thomas R. Stenger consistently encouraged the use of his extensive collection covering the history of Tacoma. And council member Bill Evans is the coauthor of this work. Indeed, if he had not applied the proper pressure, the history of Tacoma's Proctor District likely would not have been written.

To create this story, we have relied substantially on those librarians who created both the Tacoma Public Library Northwest Room Photograph Collection Index and the Housing and Building Index. Because of their constant help on the project, we have dedicated the Proctor history to them. Space requirements do not allow a complete numerical reference for the photographs provided by the library. These are, however, in both the author's and the Tacoma Public Library's files. In addition to library resources, the collections of Ron Karabaich, Thomas Stenger, and a long list of neighborhood contributors were equally valuable. Writing the history of the Proctor District also relied on the newspaper links provided in the Building and Housing Index. In using images from these articles, a good faith effort has been made to obtain permission to reproduce.

INTRODUCTION

In 1883, when Allen C. Mason arrived in Tacoma, he would have seen an embryonic city rather than the urban metropolis that builders envisioned in their dreams. Standing downtown, he might have looked north to the forests beyond the extant New and Old Tacoma settlements and wondered if his future would be there. After all, the Northern Pacific's Tacoma Land Company controlled most of the property downtown, and Mason wanted a development of his own. Legend has it that he came to Tacoma with only a few cents in his pocket, but was able to turn his spare change into a fortune only to lose it again in 1893 when an economic depression struck the world.

Within six years, when Mason was only 34 years of age, he had started to put his development dreams into reality. Establishing a newspaper headquartered in Old Tacoma, he used it to advertise his North End land developments. He platted land, donated a park to the City of Tacoma, and antagonized the Northern Pacific Railroad Company by promoting Old Tacoma as the area where commercial development should really occur. He envisioned tree-lined boulevards emanating out from his perceived downtown in Old Tacoma and built houses in the North End that showed his concept of a beautiful neighborhood. If urban planners were present within the world concept in 1889, Allen C. Mason would have been one.

In the 1880s and 1890s, the area located north and west of Tacoma's downtown was forested, and there were no graded streets. Mason therefore began with the obvious notion that public transportation was needed to get people to and from his proposed development in the North End. The result was the Point Defiance streetcar line, which ran from downtown to his platted land. The route crossed gulches where Mason built bridges and then wove through the forests to the end of the line. At first, wood-burning steam-driven engines pulled the trolleys and wood yards situated along the line provided the fuel. One such yard lay on what would become North Proctor Street, and it—along with a planning mill that arose close to the site—marks the beginning, in 1890, of the Proctor District.

Mason's streetcar route traveled west along modern-day North Twenty-sixth Street and then made a sharp north turn onto what was originally called Jefferson Street. Some of the first users were probably horse racing advocates who got off near this turn to walk a ways south to the track once situated where the Safeway store is now. Once such a stop was established, business entrepreneurs could easily see the potential of building any kind of commercial enterprise to attract the rider. Businesses would draw more businesses, and then families would come to build houses away from what many saw as the steamier side of Tacoma's downtown. After families came churches and schools—the symbols of a settled community.

In this manner, the Proctor streetcar suburb was formed. Though providing the site of the original wood yard, the records do not reveal the name or location of the first businesses in the district. Recorded time in the neighborhood began with the 1890 establishment of the first Mason Methodist Episcopal Church that early Sanborn Insurance maps show on the southwest corner of North Proctor and Thirty-second Streets. Washington School followed in 1901, meaning that at

least by this time there were a substantial number of both Methodists and schoolchildren already present in the neighborhood.

By the outbreak of World War I, the essence of the Proctor District became clearer. Wood-framed business blocks stood at the key corner of North Twenty-sixth Street, including shops like Washburn's Market and Wilmot Ragsdale's Proctor Pharmacy. The future site of the North End Tavern and the Steak House sat farther down North Proctor at the corner of North Twenty-seventh Street. Owners and developers constructed a wide array of houses ranging from small cottages and Beaux Art bungalows, whose designs were drawn from pattern books, to architect-designed residences housing some of the city's well-known entrepreneurs. By 1911, the neighborhood also had its own fire station.

The automobile began to change the appearance of the Proctor District streetcar suburb beginning around 1918. The transition between the two modes of transportation is seen in photographs where Ford Model Ts share the streetscape with streetcars. Gradually, however, the roads were transformed, first through the use of creosoted Douglas fir woodblocks and then through asphalt. When parking became a challenge, some builders pondered the possibility of putting lots on the roofs of their new buildings. The automobile also invited a new phase of construction in the Proctor District. Brick business blocks replaced and added to the older wood structures. Service stations and car dealerships appeared, some professionally designed. The neighborhood sported two silent and then sound motion-picture theaters. And as a sign of the growing number of schoolchildren in the area, Mason Intermediate School opened in the fall of 1926.

The purpose of this history is to provide the essence of Tacoma's Proctor District from its origins in the North Tacoma woods to more recent times. Chapter one introduces the reader to the district's beginnings, explains Allen C. Mason's role in the endeavor, and determines why Proctor became the moniker for the neighborhood. Chapters two and three offer a portrait of the district's transformation from a streetcar suburb to one dominated by the automobile, showing primarily the business development along North Twenty-sixth and Proctor Streets. Featured in chapters four and five are the specific institutions, including schools, that have made the Proctor District the unique entity that it is today. Neighborhoods are living places with people, and in chapter six, the reader is introduced to some of them. Several of the streetcar stops located east and north of the Proctor neighborhood are highlighted in chapter seven. Finally, chapter eight brings the story closer to the present.

Beyond the pictured streetscapes and buildings, remember that it was the people who made the Proctor District. The fabric of life was an ethnic and cultural mix—a microcosm of the city at large. Individuals worked together for the benefit of all, forming a community while living within the tight framework of a neighborhood.

One

THE BEGINNINGS

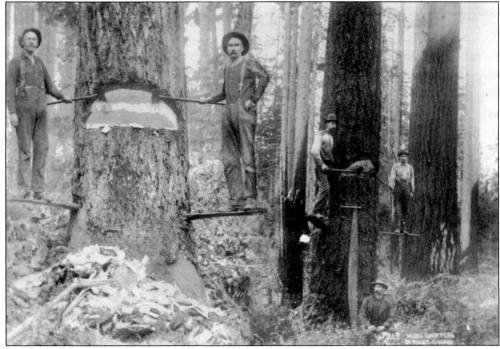

In 1873, when the Northern Pacific Railroad selected the south shore of Commencement Bay as its terminus, the bluffs overlooking the wharves were covered with a dense forest. The tangled web of undergrowth beneath the cedar and Douglas fir made travel through the woods a challenge. So too did the swamps created by the rains and snows. Early settlers were therefore also loggers, as land was cleared for urban development and Tacoma gradually expanded outward from the railroad terminal wharves. The first settlers would have heard the sounds of dynamite explosions and endured the smoky air while stumps and undergrowth made way for streets and buildings. Tacoma's Proctor District, located some two miles west of downtown, was created in this fashion, but it was a gradual process as the technology was not there to quickly clear-cut the land. (Photograph by Thomas Rutter.)

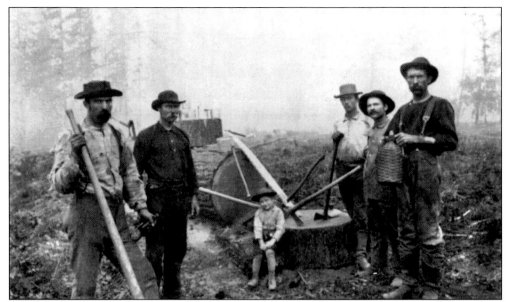

The logging of Tacoma's North End is a story yet to be told. Portable mills were scattered throughout the area, with the Northern Manufacturing Company mill located in the Proctor District between North Twenty-seventh and Twenty-eighth Streets. Photographer Hattie King captured this group logging Wrights Park in 1885, and it can be surmised that similar folk also helped clear other parts of Tacoma's urban forests.

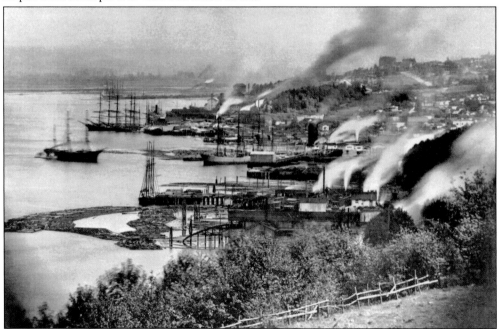

By 1907, developers could cart their logs to one of the many mills lining Commencement Bay below the city's North End. In 1889, Allen C. Mason considered building a mill, but the idea never became a reality. The *Tacoma Ledger* newspaper reporter announcing his intent called Mason the "Weyerhaeuser of the Pacific." This photograph was taken from Allen C. Mason's estate on North Stevens Street.

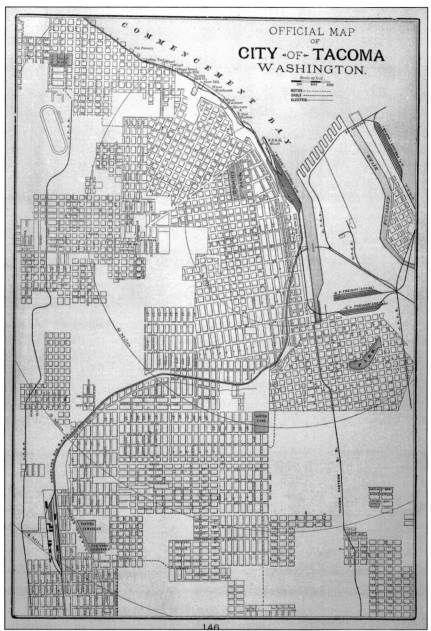

146

In the 1880s, before the advent of the streetcar, Tacomans traveled to the far reaches of the North End to enjoy the sport of horse racing. Not much has been written about the facility, and its date of construction is unknown. It is visible, however, in the upper left corner of this map. Racing adherents situated the track west of North Union Avenue on land owned by the state. With time, bicycle racing and general track events replaced the horses, and eventually the wood from the judge's stand was used to construct a house on North Washington Street. Though this map is undated, it was likely created in the early 1890s. Jefferson would become North Proctor Street. The mapmaker, a little unclear as to the location of the streetcar line, documents it running along North Washington Street to Puget Park. Another rail line runs north and terminates close to the racetrack, where riders could transfer to the streetcars heading to and from downtown Tacoma.

11

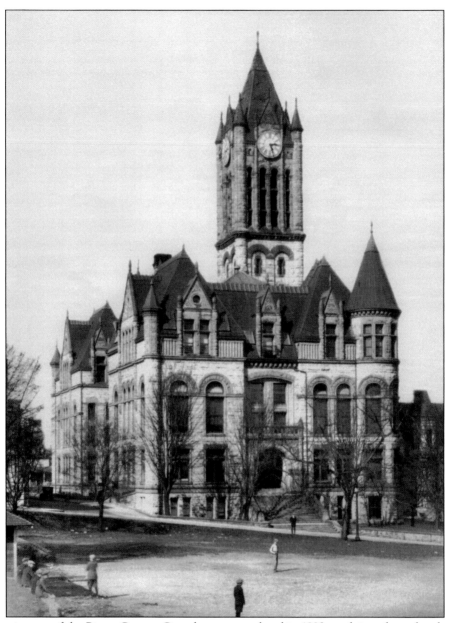

The existence of the Pierce County Courthouse, completed in 1893, explains why today there is a Proctor—not a Jefferson—District in Tacoma's North End. Upon discovering that there was already a Jefferson Street downtown, the city council had to come up with another name for the suburban street. Members settled upon Proctor to honor the architect of the courthouse. When John G. Proctor died in 1925, *Pacific Builder and Engineer* called him "an aggressive pioneer in the architectural field in the West," having designed one of the earlier Washington State capitol buildings, now the Department of Education offices. In 1890, he designed and built his family home in South Tacoma on a street named Ester. As the city began surveying and grading the street system and connecting the various plats into a coordinated whole, engineers linked Ester and Jefferson and, rather than calling the new roadway Ester, opted for Proctor, whose house stood on its southern end.

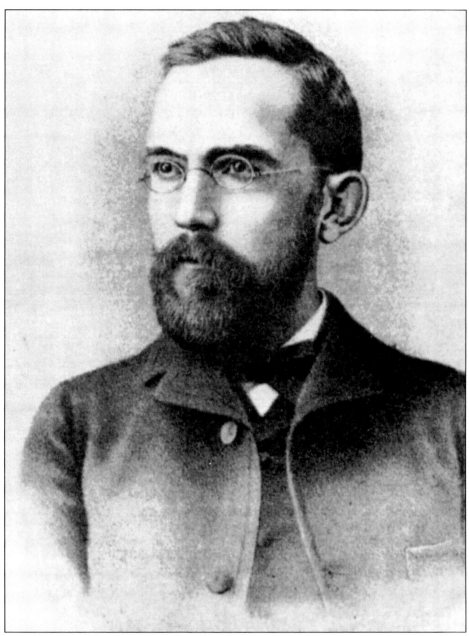

When Allen C. Mason arrived in Tacoma in 1883, he was a young man of 28 determined to strike it rich speculating in real estate. He became, according to the *Tacoma Daily Ledger*, "A signal example of that distinctive American character, the successful young man, who rises to prominence . . . with a wonderful rapidity." He was only 65 when he died in 1920, but by that time his name had become associated with the development of Tacoma's North End. Mason's contributions were many. He platted land stretching from the Proctor District to Point Defiance. His gift of Puget Park to the city, and his wish to see a system of parks and boulevards (North Union Avenue, for example), predated similar reform measures in other cities. And most important, he saw the importance of public transportation as the means to connect downtown Tacoma with the outer reaches of the city.

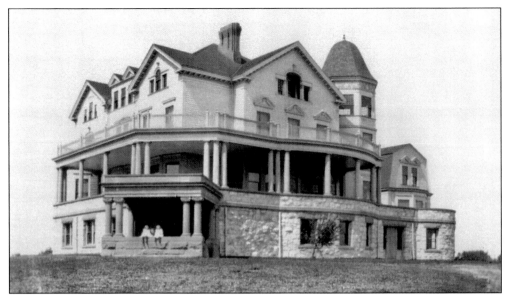

In order to encourage others to invest in the North End, Allen C. Mason built this family home, designed by architects Hatherton and McIntosh, on North Stevens Street. The house was completed in 1893 just as the world was settling into an economic depression. The Mason family, in order to recoup their finances, sold the property to Whitworth College in 1899. The school remained there until 1913.

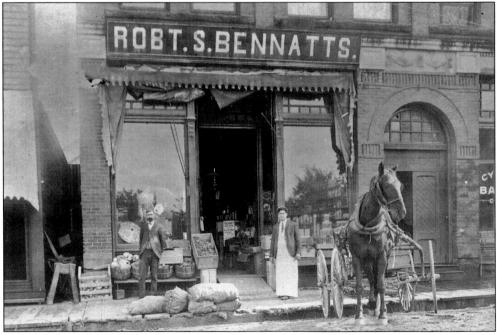

Mason did not plan for a business district along North Proctor Street. Instead, he viewed Old Tacoma as his commercial node, one that he thought could compete with the Northern Pacific terminus. In 1889, he built the Pioneer Block with R. S. Bennatts as his first tenant. Old Tacoma never fulfilled Mason's expectations, and Bennatts moved his grocery business to the corner of North Thirty-fourth and Proctor Streets.

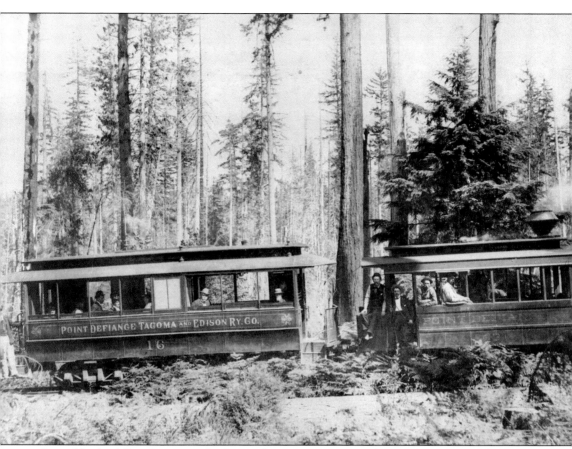

It would take Allen C. Mason's bridges and streetcars to create the Proctor District. Those who ride Pierce Transit bus No. 11 today follow the route Mason and his partners—Hugh C. Wallace, Isaac Anderson, Thomas Wallace, and Stuart Rice—built to transport commuters to and from the North End. In order to acquire a franchise from the city, Mason constructed bridges that crossed the two gulches on North Twenty-first and North Proctor Streets. In this unspecified view, a wood-burning streetcar is posed within Tacoma's *c.* 1890 forested terrain. The first passenger stops were an informal affair; the streetcar would simply stop where people congregated. The future Proctor District was an ideal site for a stop, since the cars from South Tacoma (Edison) terminated there. If people congregated in this urban wilderness, businesses and houses were soon to follow.

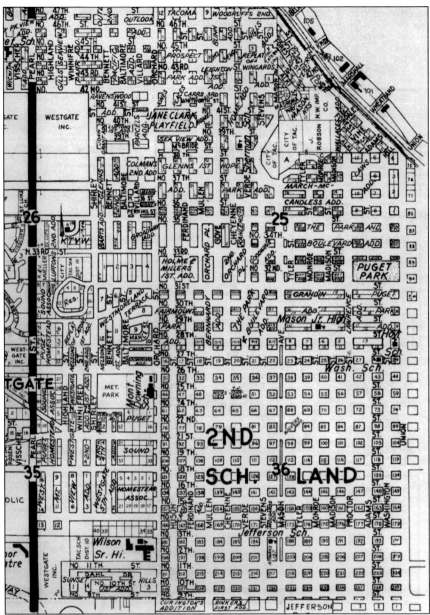

After Americans began to move West and the land was platted into a national grid, Congress mandated that two sections in every township be reserved to benefit public schools. Section 36, in the southeast corner of this undated Metsker map, is the school land located within the Proctor District. The state did not plat this part of Tacoma, whose northern border was between North Twenty-seventh and Twenty-eighth Streets, until 1902, thus hindering neighborhood development for a time. Just north of the school land along North Proctor Street, however, Allen C. Mason's park and boulevard additions were by this time platted and ready for sale. In order to lure home owners and buyers of lots, in 1889 Mason had E. E. Thayer design and the Wapato Mills construct two houses (now gone) at 2720 and 2722 North Proctor Street. In 1902, Ollie Hiller became the first known resident to build on school land. His house, at 2823 North Proctor Street, was demolished after World War II to allow for the expansion of Mason Junior High School.

16

Two

A Streetcar Suburb

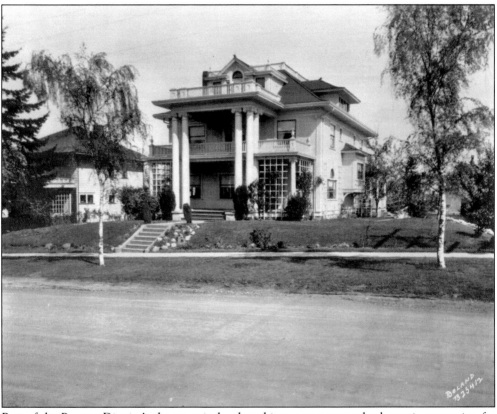

Part of the Proctor District's charm as it developed into a streetcar suburb was its attraction for those who wanted their families to live away from downtown Tacoma. The end result was a wide array of homes ranging from the small bungalow to the palatial, such as the John Q. Mason residence at 2501 North Washington Street. John Q.'s wife, Virginia, is credited as the architect for this neoclassical wonder completed in 1905. When John Q. died in 1920, he was viewed as one of Tacoma's pioneer entrepreneurs. Virginia, however, got more press attention primarily because she established her home as a community center for suffragettes, including local advocate Emma Smith DeVoe. By 1916, Virginia, after already having served on Pierce County's first all-woman jury in 1911, was an officeholder in the National Council of Women Voters. Another Proctor resident, Mrs. G. A. Plummer, served as national treasurer of the council. (Photograph by Marvin Boland.)

In 1907, when the *Tacoma Daily Ledger* reported the completion of the Frank Pittman house at 3756 North Twenty-eighth Street, the writer pointed to it as "an example of Tacoma's medium priced modern homes" available "at a cost of about $3,000." Pittman, district manager of the Pacific Coast Merchandise Company, retained C. W. Jones to both design and build the home and lived there with his family until 1915. A robbery that year probably prompted Pittman to sell to J. F. Hopkins. "The burglars," stated the *Ledger*, "were discovered at work but escaped while Mr. Pittman endeavored to get his key in the keyhole. . . . The burglars showed unusual knowledge of laces and lingerie," for the best were stolen, along with $1,000 worth of jewelry, silver, and heirlooms. Det. John Strickland arrested I. T. Claussen for the deed, but the final disposition of the case is unknown.

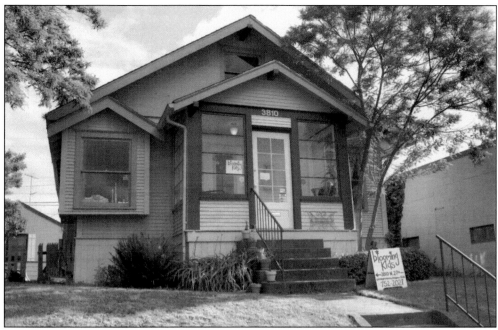

Snuggled between a new professional office building and a not-so-new commercial building and across the street from today's post office are two houses built during the early years of the Procter streetcar era. A. C. Bell served as contractor for the 1909 house (above), located at 3810 North Twenty-seventh Street. Oliver F. Mickle, a streetcar operator for the Tacoma Railway and Power Company, bought the residence sometime in the spring of that year. The record is unclear about the first owner of the 1910 house (below), constructed next door at 3808. The *Tacoma Daily Ledger* reported the issuance of a building permit to Roscoe S. Steere. He might have had the house built, but he did not live there at the time. The Christian Science practitioner resided instead at 3710 North Twenty-fifth Street, two blocks away.

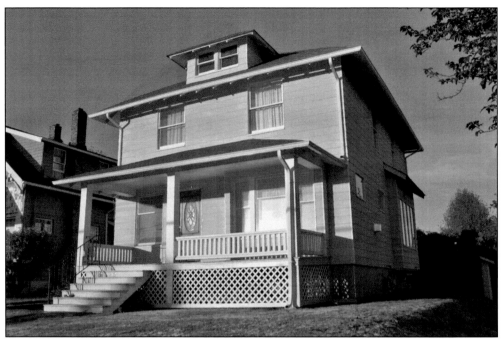

Postman John S. Clemmons moved into this house, located at 2801 North Proctor Street, in 1910. His son Albert and his daughter Carrie V., a stenographer, lived with him. "The house," reported the *Tacoma Daily Ledger*, "is modern in every aspect and combines in its appointments both elegance and convenience. The residence is pleasantly situated in a locality being rapidly improved."

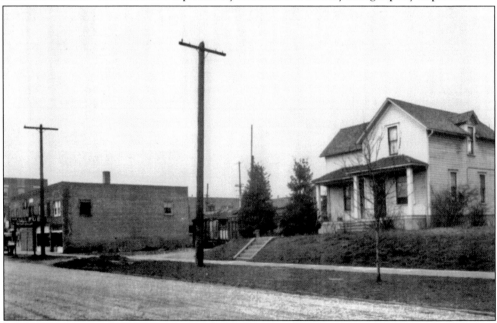

In 1935, Stanley Morrison, president of his own real estate company, had the Richards Studio photograph the house—then occupied by Lucas Rudolph—at 3815 North Twenty-seventh Street, for unknown reasons. The house no longer remains. The Freemason Hall, located west of today's Proctor postal station, replaced the structure.

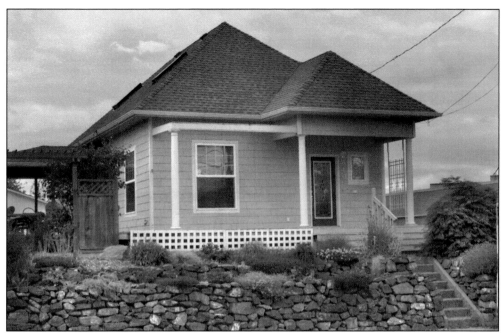

Houses once lined North Proctor Street south of the streetcar line. The two shown here are unique because they still grace the streetscape. The 1905 house (above), at 2510 North Proctor Street, was constructed for Catherine A. Heuston and was one of the first to appear south of North Twenty-sixth Street. At the time, Heuston was a widow living with her two children: Benjamin, a student; and Elizabeth, a retoucher for A. L. Jackson, one of Tacoma's first photographers. In 1907, Cornelius H. Beck became their next-door neighbor at 2506 (below). Beck was a partner in the George Russell and Company real estate firm.

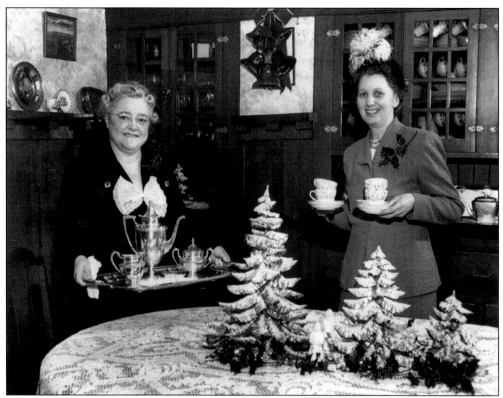

Rarely is there an opportunity to peek inside a Proctor neighborhood bungalow. This house, located at 4022 North Twenty-seventh Street and built for Clarence Fogg in 1915, was the home of Cecil and Daisy Blogg in the 1940s. A Richards Studio photograph captured Daisy (left), president of the Elementary Grade Club, and Martha Holden, head of the Association of Childhood Education, planning a Christmas tea party in 1948 that would benefit students at Washington school.

In 1907, Andrew Larson built a grocery store at 4202 North Twenty-seventh Street in order to provision those living three blocks west of the streetcar that ran along North Proctor. By the time a Richards Studio photographer captured this image in 1951, however, grocer Boe Pederson had converted the store into a single-family home.

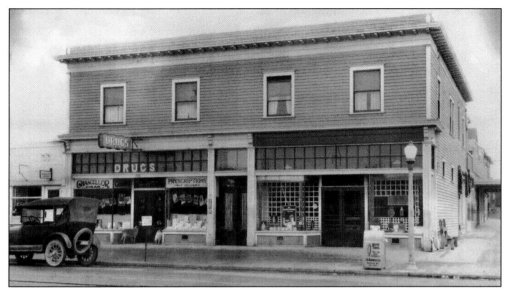

Architect Vere Barton designed a commercial building for Michael D. Coleman at 3822–3824 North Twenty-sixth Street in 1908. In the 1920s, when an unknown photographer captured the storefront, T. E. and Ida Hutchinson owned the grocery store to the right. Wilmot P. and Amy Ragsdale owned the Proctor Pharmacy and lived upstairs. The Ragsdales provided free delivery, so the car parked in front of the Quality Laundry store is probably theirs. (Photograph by M. W. Marush.)

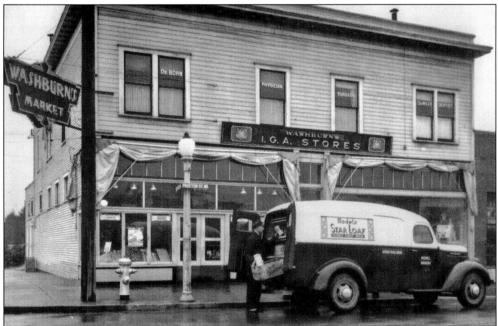

In 1917, Wallace and Ella Washburn established a meat market and grocery store at 2602 North Proctor Street in a building owned by Carlos Jacobs. The business remained in family hands until 1966, when a gas station replaced the older structure. Carlos and his wife, Hattie, lived upstairs in 1939, when this Richards Studio photograph was taken. So too did Dr. Julius C. Bohn, who was deemed "family doctor of the year" in 1951.

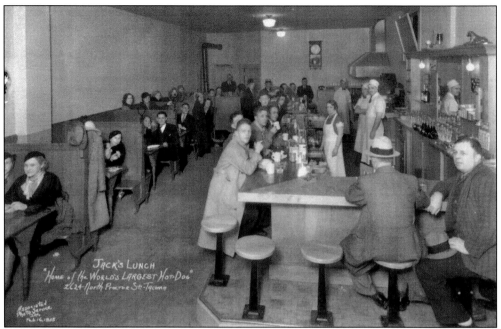

In 1935, when Chapin Bowen took this interior photograph at 2622–2624 North Proctor Street (above), one storefront was occupied by John Bolton's Jack's Lunch, a restaurant boasting the "World's Largest Hot Dog." Three years later, Bolton opened the adjacent Jack's Tavern, soon to be renamed the North End Tavern. By 1940, the restaurant was under the new management of Ella Pauschert. (Her husband was a driver for the Cooney Transfer and Storage Company.) Before opening on November 30, Ella had completely remodeled the café (below), adding "spotlessly clean and gleaming with chromium trimmed counters," according to the *Tacoma News Tribune*. Sundays were to be reserved for family dinners. (Above, Jack's Lunch; below, Richards Studio.)

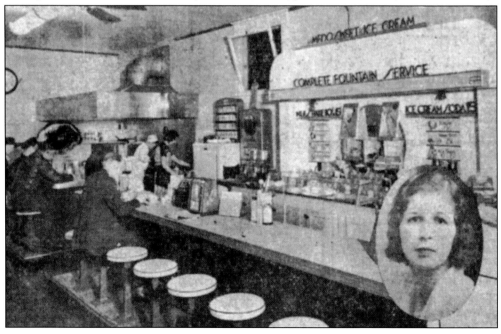

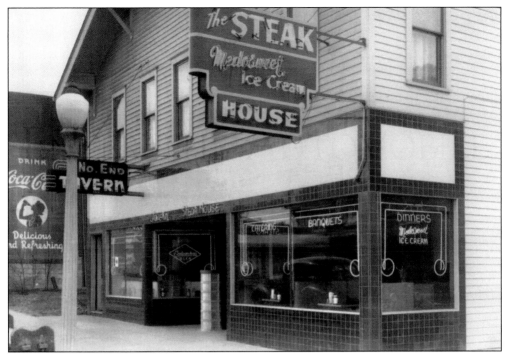

By 1944, the restaurant at 2624 North Proctor Street—originally built in 1910 as the J. H. Leonard Store—had morphed into the Steak House, owned by Ted A. Clark. The exterior view (above), taken by a Richards Studio photographer the same year, shows the building's original gable roof and the second-story apartments where Jack and Ethel Bolton once lived. Next door was the North End Tavern, owned by David Metcalf. No doubt Clark was inspired to have photographs taken because the restaurant's interior had been remodeled once again (below). Art Moderne replaced Ella Pauschert's Art Deco at the soda fountain, and the space was expanded to include a separate dining room.

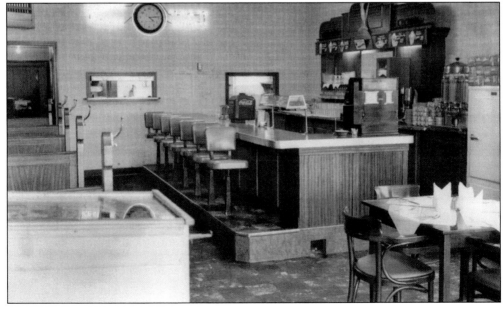

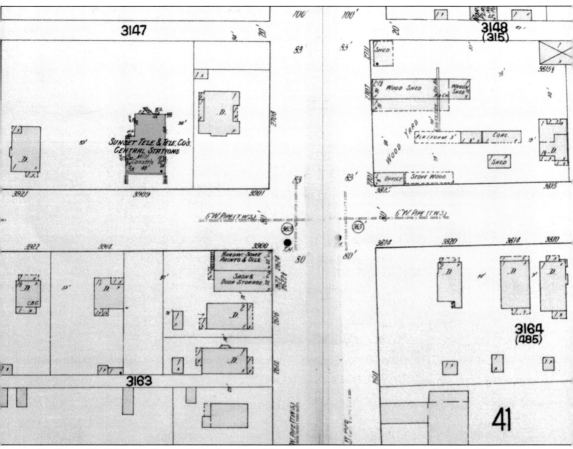

On June 18, 1911, the Sunset Telephone and Power Company, headquartered in San Francisco, announced plans to construct a new substation in the Proctor District. This Sanborn Insurance map of the area shows its location at 3909 North Twenty-seventh Street. The construction firm of Westerfield and Van Buskirk was hired to build the facility. Underground street cables were connected to the power plant on the second floor and then linked to the switchboards on the third. Telephone operators worked from the first floor. The company decided to build in the Proctor District because of rapid growth within the North End, and the substation was designed to serve 10,500 customers. The building remained a community landmark until its demolition in 1975.

Three

ENTER THE AUTOMOBILE

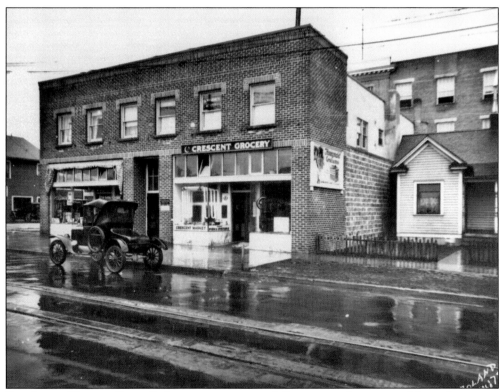

For almost 50 years, Point Defiance streetcars took Proctor residents to and from downtown Tacoma. These trolleys, however, were becoming obsolete by the 1920s after Henry Ford delivered the Model T to the American populace. The new contraption expanded the user's horizons and revolutionized whole neighborhoods. Streets began to look different when the automobile, combined with new concepts in architecture, meant brick buildings and the presence of service stations on just about every corner. Proctor District entrepreneurs joined the wave of change by replacing wood-frame houses such as Dr. Stewart's, seen here at 2708 North Proctor Street, with new brick commercial structures like the Davies Building, located at 2702 North Proctor and completed in 1924. A Model T signals the future, while the streetcar tracks remain, leading a few folks to believe the automobile just a passing fad.

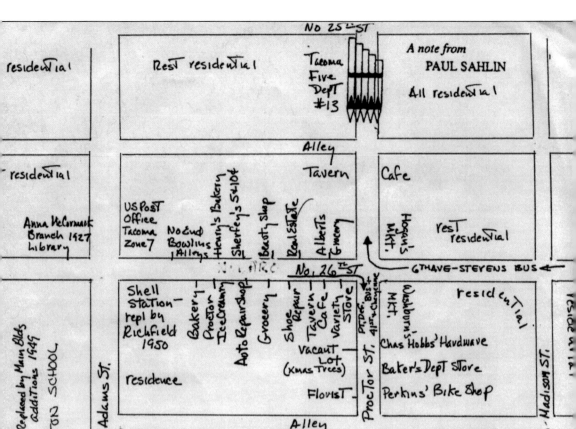

In 1997, neighborhood resident Paul Sahlin sat down and recorded the Proctor commercial area as he remembered it between 1945 and 1954, the years of his youth. The map he drew is shown here and on the following page. The Sahlin family lived at 4009 North Twenty-seventh Street, "just about where the pulpit is in the Mason ME church." This part of the map covers North Proctor Street from the fire station on North Twenty-fifth Street to the alley situated between North Twenty-sixth and North Twenty-seventh. The post office stands on the northwest corner of North Adams and Twenty-sixth Streets. Within one block, everything from a service station, bowling alley, more than one grocery store, cafés, taverns, and variety stores crowd the street. Sherfey's Five and Dime has replaced the Paramount Theater, once located at 3618 North Twenty-sixth Street. The residential neighborhood surrounds the commercial area. (Bill Cammarano.)

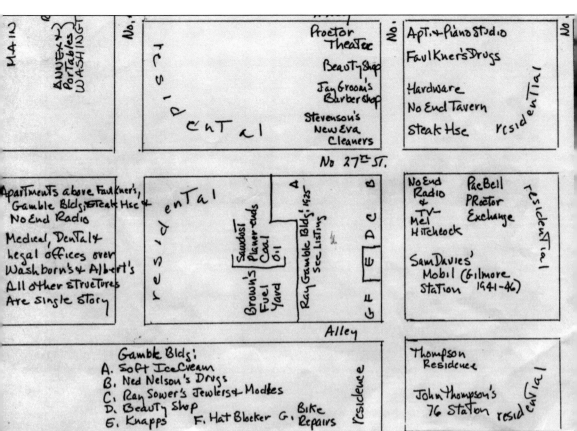

The map contains the following handwritten labels:

MAIN

AWNINGS & PortableS WASHING

No.

residential

Proctor Theater

Beauty Shop

Jay Groom's Barber Shop

Stevenson's New Era Cleaners

No.

Apt. + Piano Studio

Faulkner's Drugs

Hardware

No End Tavern

Steak Hse

residential

No.

No 27ᵉ ST.

Apartments above Faulkner's, Gamble Bldg; Steak Hse & No End Radio

Medical, Dental & Legal offices over Washborn's & Albert's All other structures Are single story

residential

Brown's Fuel Yard — Sawdust, Planer-ends, Coal, Oil

Ray Gamble Bldg; 1425 See Listing

A
B
C
D
E
F
G

No End Radio & TV — Mel Hitchcock

PacBell

PRoctor Exchange

Sam Davies' Mobil (Gilmore Station 1941–46)

residential

Alley

Gamble Bldg;
A. Soft IceCream
B. Ned Nelson's Drugs
C. Ray Sower's Jewlers & Models
D. Beauty Shop
E. Knapps F. Hat Blocker G. Bike Repairs

residence

Thompson Residence

John Thompson's 76 Station

residential

The second part of the map depicts the Proctor District from the alley between North Twenty-sixth and Twenty-seventh Streets to North Twenty-eighth Street. Sahlin remembers the Proctor Theater interior as having "lots of pastel pink and green, very Art Deco colors and shiny burgundy tile at the popcorn stand in the lobby." Brown's fuel yard, with sawdust, planer ends, coal, and oil, was located behind the Gamble Building. In the late 1940s, Knapps Restaurant offered hamburgers for 15¢. Sam Davies and John Thompson owned two of the three service stations in the Proctor District, with the Thompsons living in their own house next to the business. While riding his bicycle past these stations in August 1945, Sahlin saw cars stopped in the middle of North Proctor Street, the drivers getting out of their vehicles and hugging each other. The youngster was witnessing the end of World War II. (Bill Cammarano.)

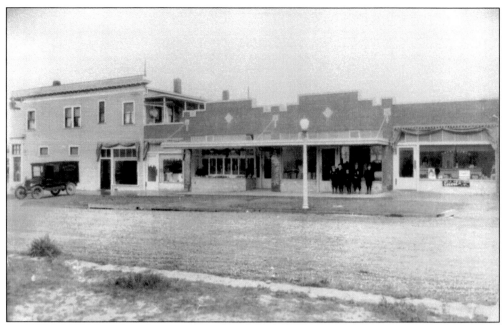

By 1925, M. W. Marush had acquired the wood-frame building situated on the southeast corner of North Twenty-sixth and Proctor Streets and proceeded to build a new brick structure south along Proctor. E. J. Bresemann designed the building, with its roof of parapets and metal marquis. The owner of a downtown fish market located on Broadway, Marush lived in Old Tacoma. (Photograph by M. W. Marush.)

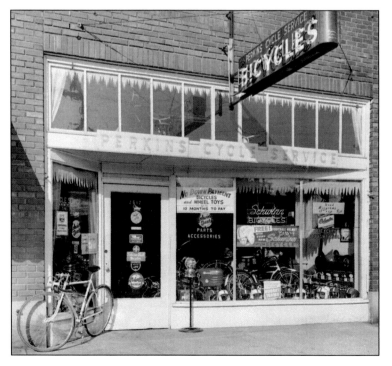

Peter Wallerich was constructing a new brick building on the 2600 block of North Proctor Street at the same time as Marush. Proctor Hardware and Emory Baker's department store were early businesses located there. No photographs of the building have been found, but the Perkins Cycle Service may have occupied one of the storefronts in 1947.

The June 21, 1925, *Tacoma Daily Ledger* reported that E. D. Murphy would build a two-story concrete structure "just across the street from the Blue Mouse moving picture theater." Shown above, it was advertised as being "in the heart of a small but prosperous business district" that was a "convenient place to live, close to schools, theater, library and on the streetcar line." The building, whose second floor included five apartments, cost a total of $5,000. The first floor was home to Faulkner Drugs for 46 years. Eventually, it also housed Faulkner's Apparel, run by Mildred Faulkner for 18 years. After her daughter assumed ownership, she operated Marilyn's Fashion World for another 25 years. Marilyn, at left in the image to the right, was a strikingly beautiful woman and a renowned Tacoma business entrepreneur who set the tone for women's fashion in the city.

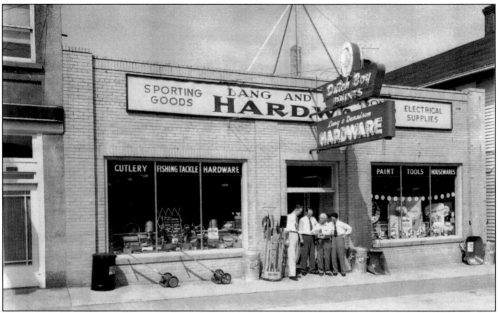

By the end of 1945, World War II was over. Roosevelt, Churchill, and Stalin had met in Yalta in February to plan postwar Europe. By May, German troops had surrendered and the Allies declared V-E Day. The war in Asia continued, however, until the Allies' controversial use of the atomic bomb on Japanese cities and the proclamation of V-J Day on August 15. In November of that year, as troops were returning home, Proctor District grocer W. A. Washburn announced the construction of a new brick building at 2616 North Proctor Street on the previous site of his house. By 1952, the structure was home to Lang and Dennison Hardware (above), where inside one wall was lined with cans of paint (below). Vern Baldwin bought the business in 1958 and ran it for 35 years as Proctor Paint and Hardware. (Richards Studio.)

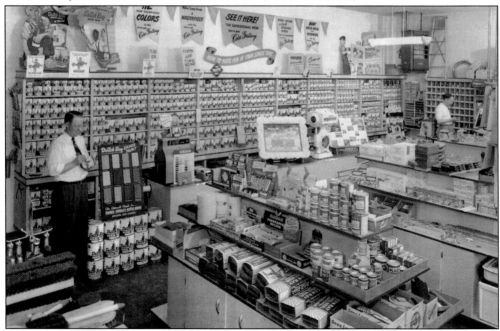

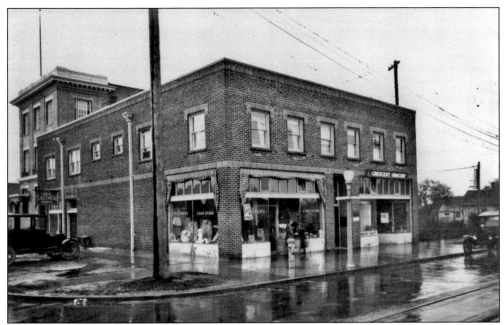

Today city planners encourage mixed-use buildings in neighborhood commercial districts. "Build walkable communities" is their mantra. In 1924, James Davies did exactly that. He built what the newspapers described as an "apartment–office–retail store building" (above). The first-floor tenants were Emory Baker with his "cash only haberdashery," Crescent Market, which sold "staple and fancy groceries," and Ace Sheet Metal Works. Upstairs were apartments and the offices of a dentist and a physician. Pacific Telephone and Telegraph's four-story Proctor Exchange Building stood on North Twenty-seventh Street. Mel Hitchcock's North End Radio (below) came in the 1950s. It employed "Tacoma's Top TV Technicians," who would bring the "Try-A-Tenna" wagon to your home to help get better reception. Since the 1980s, the Harp and Shamrock and the Pacific Northwest Shop have occupied these historic retail spaces.

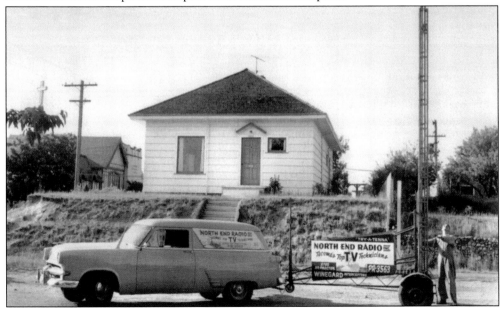

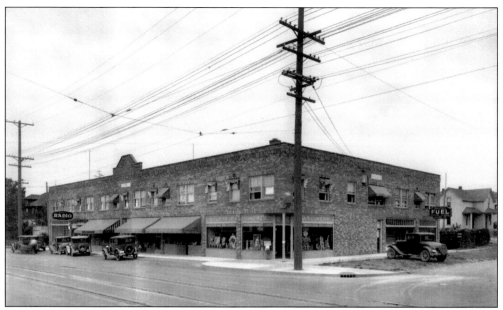

In 1900, Ray Gamble was a young paperboy whose *Tacoma Daily Ledger* customers included a man named Anderson who lived on the corner of North Twenty-seventh and Proctor Streets. Gamble bought the land in 1929, and Marvin Boland photographed the completed Gamble Building (above) in 1930. Brown Fuel Company occupied the southern storefront, and a pharmacy had the corner space. Local residents could buy a radio in the shop farther down the street. During its long life, the building has housed numerous other businesses such as Sower Jewelers, Kuehn Real Estate, and Proctor Antiques. The Chic Styling Salon was one occupant in 1961. Owner Bette La Pore (below) poses for a Richards Studio photograph. The curious will have to peruse Tacoma city directories to identify the hundreds who rented apartments upstairs.

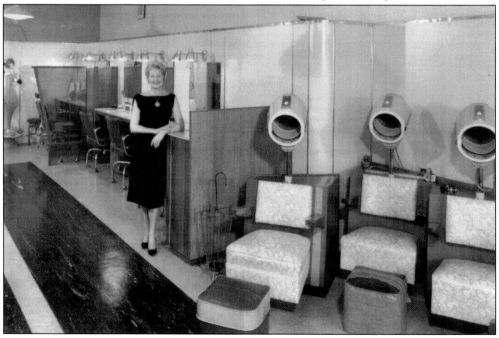

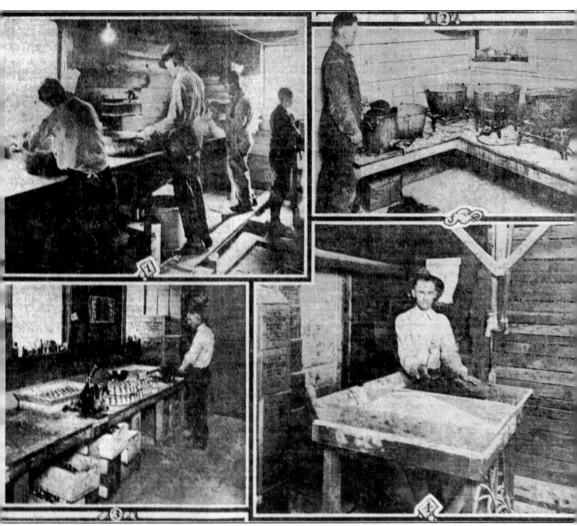

These men worked for the Chemical Products Company at 2709 1/2 North Proctor Street, a business on the site where Ray Gamble constructed his building. In 1921, the *Tacoma Daily Ledger* called it "the Factory Where Popular Brand Fishing Bait is Manufactured." These photographs show salmon eggs being preserved, dried, and filled in jars prior to their shipment east. According to a report at the time, "They are proving a revelation to Eastern fishermen who have never used prepared salmon eggs for trout fishing." The salmon roe came from Alaska "in special made barrels containing 400 pounds of eggs." The Chemical Products Company was expecting a delivery of some 500 barrels in 1921. When the newspaper published this article, owners were planning to move downtown because they were running out of space and needed to be closer to shipping facilities.

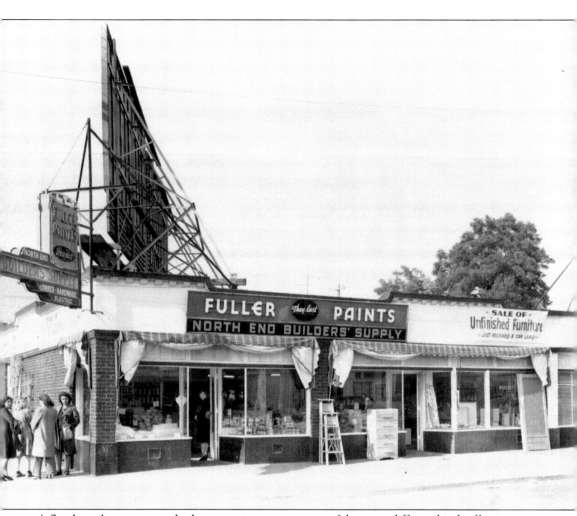

A floral supply company and a department store were some of the many different kinds of businesses occupying this building after its construction in 1919. The facility, located on the northeast corner of North Twenty-sixth and Proctor Streets, housed the North End Builders Supply Company in 1943. Operated by Edwin L. Coy, the firm offered unfinished furniture next door, no doubt as a way to encourage customers to buy the Fuller Paints available in the store. Besides running the business, Edwin Coy was a Baptist minister serving as pastor for nine area churches during his career. The places of worship were always financially troubled, and Coy took other jobs to support his family. This image offers an interesting view of the Proctor District during World War II, as the people captured by the Richards Studio photographer are all women. Perhaps they are headed to the Blue Mouse Theater, seen in the distance on the left, for a matinee.

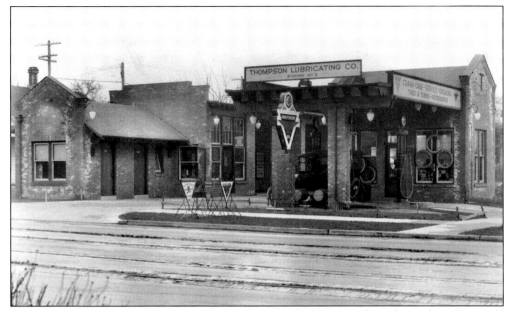

The year 1925 was a heady time. People could not predict that four years later the stock market would crash and the Great Depression would send the country into a tailspin. In 1925, unemployment was only 3.2 percent nationwide and a first-class stamp cost 2¢. President Coolidge proclaimed, "The business of America is business." And through it all, Tacoma and the Proctor District prospered. John Thompson, who lived with his family on North Proctor Street, applied in 1925 for one of the first permits to build a service station in Tacoma, seen above. A brick building designed by the architectural firm of Hill and Mock, it was located on the southwest corner of North Proctor and Twenty-eighth Streets. In 1941, Clifford Gibson built a second station on the same block. In the mid-1940s, he leased to Sam Evan Davies, shown below in a Chapin Bowen photograph. Gas cost 8¢ a gallon at the time.

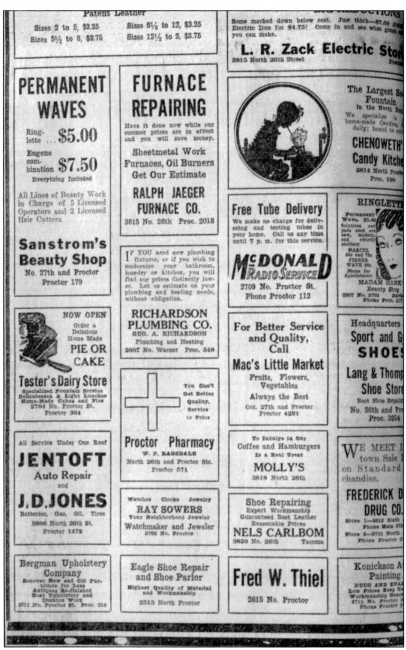

When the nation entered the first years of the Depression in the 1930s, neighborhood businesses were hit especially hard. This 1931 *Tacoma Daily Ledger* advertisement, in which "26th and Proctor Street Bids For Your Business," was one way that the neighborhood sought to cope with changing economic conditions. At Emory Baker's department store, a woman could buy an apron for 19¢. Bib overalls at Sanstrom's store cost 69¢. Other items, such as electric irons at Zach's Electric store, were marked down below cost. Women could get a ringlet perm at either Sanstrom's or at Madam Hank's in the Davies Building for $5. Proprietors of ice cream fountains, automobile, shoe, upholstery, and furniture repair stores, along with plumbers, pharmacists, jewelers, and restaurants, were all asking for the neighborhood's help during these trying times.

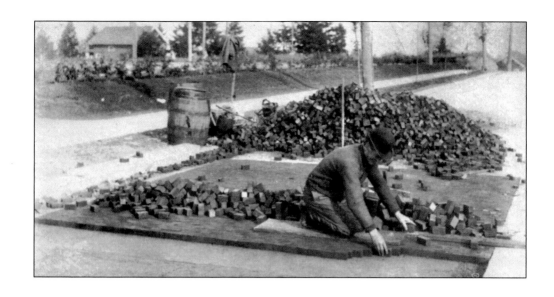

Once automobiles began to roam Tacoma, greater attention was made to the streets' surfacing. The St. Paul and Tacoma Lumber Company began to provide Douglas fir blocks as a surface and published a promotional brochure to advertise their product. Above, a worker lays the creosoted wood along North Twenty-sixth Street. Company promoters claimed that shallow blocks "make an economical as well as silent, clean and durable surface for residence streets." Seen below is a pavement that has been in service for two years. Washington School is out of view on the right. The Proctor fire station is visible in the distance.

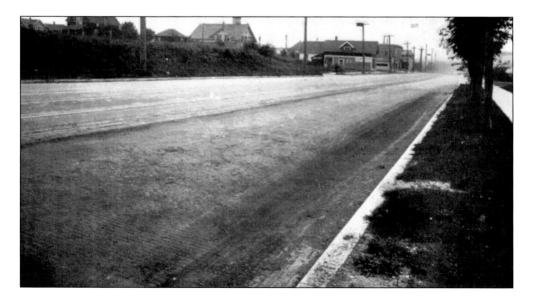

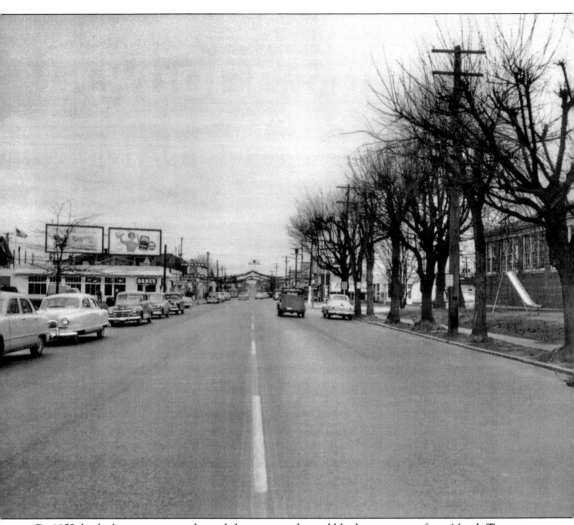

By 1953, both the streetcar tracks and the creosoted wood blocks were gone from North Twenty-sixth Street, and the North End improvement clubs had failed in their attempts to remove billboards from the neighborhood landscape. Safeway hired Richards Studio to photograph the major commercial district intersection at North Twenty-sixth and Adams Streets—along with others at North Proctor and Thirty-fourth Streets and North Adler and Twenty-sixth Streets—in order to document parking congestion. The intersections were all major stops along the original streetcar line. Washington School appears on the right in this view. Farther along that side of the street are, from left to right, a Richfield service station, Bell's Bakery, Proctor Ice Creamery, and Dahlin's Grocery. Gene's Radio and Appliance shop, North End Alleys, North End Lockers, and C&O Electric line the street on the left.

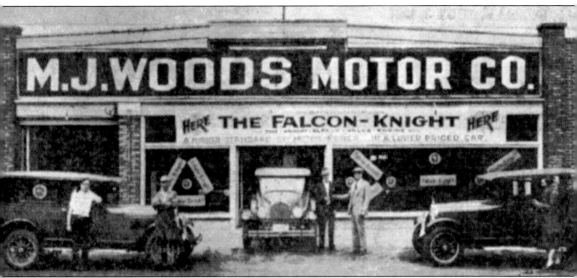

Automobile service stations and dealerships sprouted on North Twenty-sixth Street just as they had on Proctor Street. In the 1920s, the Brunswick Service Station, located on the northwest corner at Adams Street, was a "sportsman's haven," according to the 1922 *Tacoma Sunday Ledger*. Owned and operated by Harry Morse and Edwin Wallow, this modern "drive-in" automobile service station was a convenient spot for the tourist and sportsman "while preparing their cars for a spin to the gun club or for a jaunt into the wilderness in quest of game." The M. J. Woods Motor Company, shown here, was located at 3815 North Twenty-sixth Street and was, in 1927, the Pierce County distributor of the Falcon-Knight roadster. Within a year, however, the company had been renamed the Smith-Lewis Motor Company, proud distributor of the Dodge.

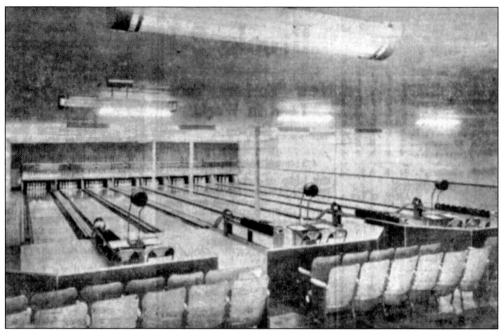

In October 1941, Al Davies and his partner, Art Dale, opened the North End Alleys (now Chalet Bowl) at 3806 North Twenty-sixth Street. Leagues had already been formed for the Kiwanis, Telephone, and North End Industrial teams. The facility was "unanimously acclaimed one of the finest in the Northwest," reported the *Tacoma News Tribune*.

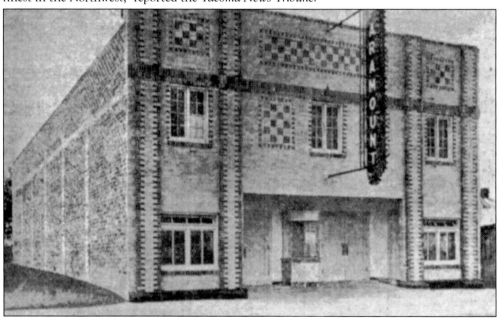

Robert McKinnell opened the Paramount Theater in 1923. A *Ledger* reporter described the facade as "tastefully designed in white pressed brick trimmed with brown." On each side of the proscenium arch were oil paintings on silk illuminated from behind. One side featured Mount Rainier (Tacoma) and the other Snoqualmie Falls. When the theater failed, the building became first a five-and-dime store and then a bicycle shop.

Four

MAGNET BUILDINGS

Throughout the Proctor District are specific buildings and structures that help to define the uniqueness and character of the neighborhood. The Mason Methodist Episcopal Church is one such entity, reflecting the importance of religion—and especially the Methodists—in the development of the American West. Indeed, missionaries from this congregation arrived in the Pacific Northwest before most settlers, and some historians argue that the Methodists were more instrumental in forging national unity than the federal government during the early years of American history. Rev. Horace Williston organized the Mason Methodist Church in the Proctor District in 1890 with 24 charter members. D. P. Hopping, at a cost of $2,624, constructed the first church building on the corner of North Thirty-second and Proctor Streets. No other churches were built at this time in the Proctor District, suggesting that most of the earliest settlers were members of this evangelical sect.

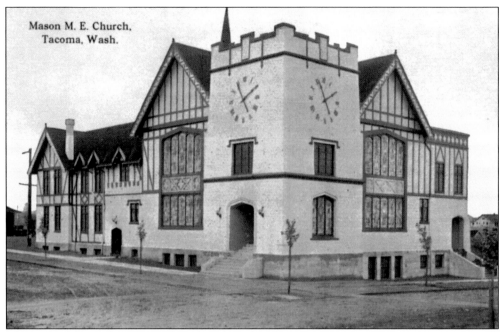

The *Tacoma Daily Ledger*'s headline on September 3, 1911, referred to the new Mason Church as "one of the handsomest structures in the Northwest." And so it was. Located on the corner of North Twenty-eighth and Madison Streets, the English Tudor–style building was designed by renowned Tacoma architect Frederick Heath. The church had a seating capacity of nearly 600 on the main floor. The congregation had grown from 24 members in 1890 to 179 by 1910, necessitating the new building. (Tom Stenger collection.)

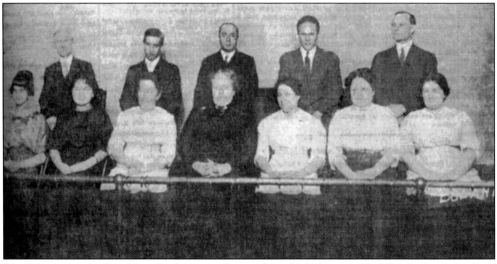

The Mason Methodist Church choir was featured in the February 15, 1914, *Ledger*. Members included, from left to right, (first row) Helen Marble, Miss Myers, Mrs. W. P. Hopping, Mrs. W. J. Carr, Mrs. C. W. McConnell, Mrs. A. W. Winden, and Lulu Marble; (second row) S. E. Walker, Louis Polly, organist E. S. Zollman, Mr. Smith, and A. W. Winden.

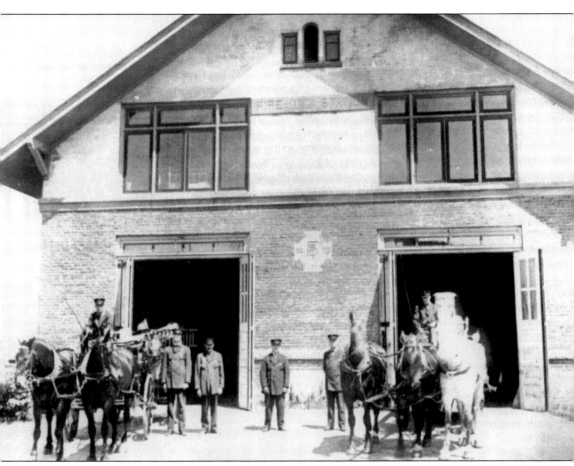

Proctor was a fast-expanding district in the early 1900s, so residents and businesses petitioned the city to build a fire station in the neighborhood. Architect Frederic Shaw designed the building that was dedicated on April 5, 1911—the same day that former president Teddy Roosevelt came to address 35,000 citizens at Stadium Bowl. The first apparatus was an 1889 Amoskeag steam-powered fire engine pulled by three horses over Tacoma's dirt and cobblestone streets. It could pump 600 gallons of water a minute. Two additional horses pulled the hose wagon. The stable for the horses was in the basement. In 1911, firefighters worked 29 straight days, had one day off, and then worked 29 more. Families came to the station to eat with the men. Members of the squad practiced twice a day, and old logbooks show that they could get the horses harnessed and ready to go in 9.2 seconds. By 1921, firefighters earned $140, captains $160, and the chief $215 a month. (Ralph Decker collection.)

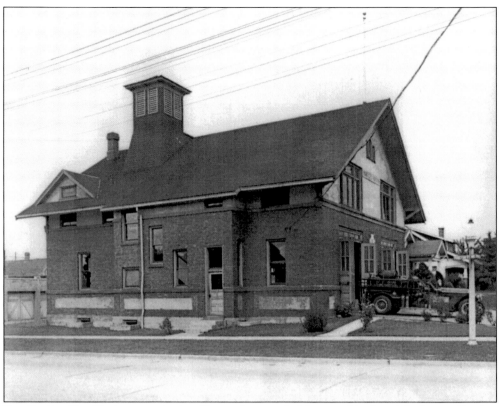

Fire Station No. 13 always ranked as Tacoma's second-oldest neighborhood firehouse. Station No. 8, built at South Forty-third and L Streets in 1909, was the oldest. That station, however, was retired and became a residence in 2005. Therefore, No. 13 is now the oldest fire station operating in Tacoma. Pictured here in the 1930s, the station—located on the northeast corner of North Twenty-fifth and Proctor Streets—still had its hose tower. (Photograph by Marvin Boland.)

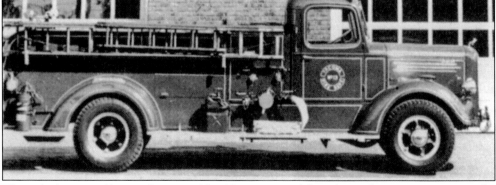

Through the years, Engine Company No. 13 transitioned from horse-drawn equipment to the most modern rigs. During World War II, it was impossible to replace severely aging equipment because apparatus builders were making supplies for the war. Pictured is the first fire truck sent to the Proctor station after the war ended, a 1947 Mack 1,000-gallon-per-minute pumper. It remained in service until 1970. (Ralph Decker collection.)

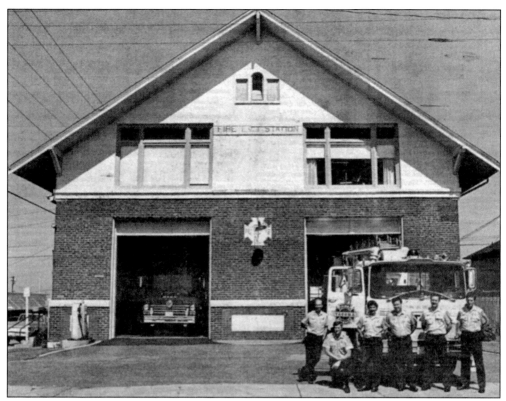

When 2003 budgetary cuts threatened the fire station's closure, union president Pat McElligott announced that members would forfeit a portion of their retirement savings—$500,000—to keep the station open. Mayor Bill Baarsma praised them for making a "historic, precedent-setting sacrifice." City council members then found the rest of the money to keep the station operational. Unidentified station firefighters are shown here in 1989. (Photograph by David Brandt, *Tacoma News Tribune*.)

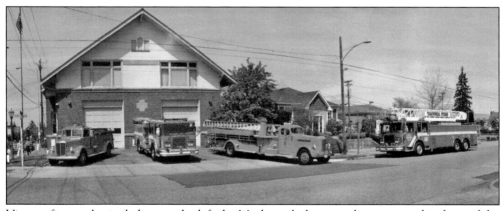

Vintage fire trucks, including on the left the Mack truck shown earlier, are posed in front of the Proctor fire station in the 1990s. The building, along with others located throughout Tacoma, was placed on the National Register of Historic Places in 1986. In the application for historic status, it was called "a significant example of early twentieth century fire house design that harmonizes with its residential neighbors." (Photograph by Ron Karabaich.)

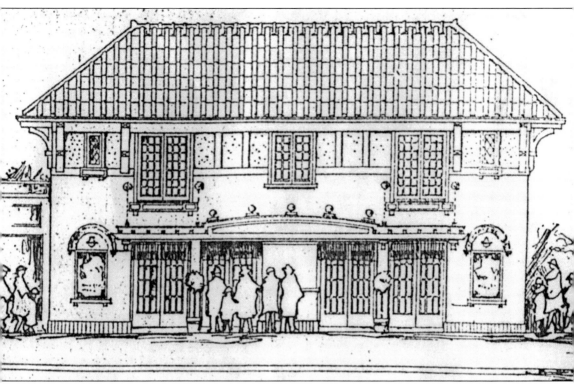

In 1923, when this *Tacoma Daily Ledger* sketch was printed, owner John Hamrick called the Proctor Street Blue Mouse "one of the most elaborate suburban theaters in the Northwest." It opened for business on Tuesday, November 13 of that year. Other than for repairs and restoration, it has remained open almost every evening since. It was named after a lounge in Paris that Hamrick had visited in 1919 that showed the latest craze: "the flicks." Henry Sanstrom built the theater at a cost of $20,000. Londoner Fitzherbert Leather designed the "garden style arts and crafts" building. House manager George C. Greenlund changed movies three times a week on Tuesdays, Fridays, and Sundays. Because a Tacoma Blue Mouse was also located downtown, the Proctor theater was called the Blue Mouse Junior.

The Green Goddess was the first silent film shown at the Blue Mouse. While the 420 attendees read through the subtitles of a story placed in India during the British occupation, the theater organist set the mood. North End businesses welcomed the new theater through a full-page newspaper advertisement on opening day, an event that included congratulatory remarks from Tacoma mayor A. V. Fawcett.

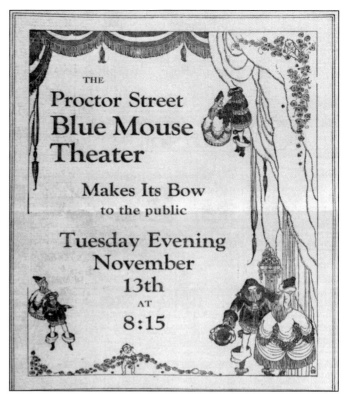

THE

Proctor Street
Blue Mouse
Theater

Makes Its Bow
to the public

Tuesday Evening
November
13th
AT
8:15

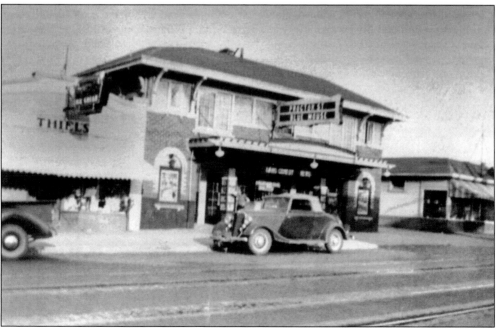

The venerable Blue Mouse, pictured in the late 1920s, experienced name changes over the years. In 1932, the theater became the Proctor and, in 1978, the Bijou. It became the Blue Mouse again in 1993. Tracks of the Point Defiance streetcar line still run in front of the building in this view. Thiel's Ice Cream shop is to the left of the theater. Sanstrom's department store is on the right.

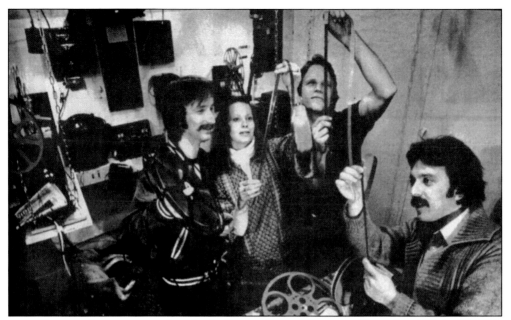

A small group of entrepreneurs bought the Proctor Street Theater in December 1978 for $80,000, renamed it the Bijou, and showed vintage films—two for $2.25. In this *Tacoma News Tribune* photograph, taken by Russ Carmack, from left to right are Greg Rediske, Paula Rediske, Jeff Rediske, and Chris Manthou. The experiment did not last, and the theater passed to a new owner, Shirley Mayo, in the early 1980s.

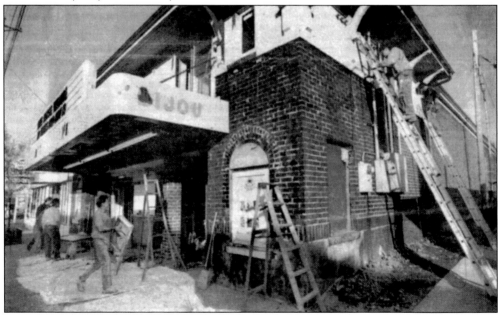

Proctor District investors acquired the theater and reopened it on February 4, 1994, showing *The Secret Garden* and *Much Ado about Nothing* to a sellout crowd. Substantial restoration work was done, as shown in this 1993 image. Architect Gene Grulich (center) and Erling Kuester (on ladder) are in the process of returning the exterior to its 1923 appearance. The restored marquee included dancing blue mice designed by artist Dale Chihuly. (*Tacoma News Tribune.*)

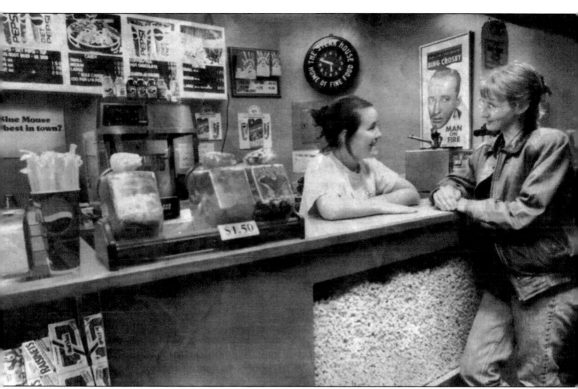

By the 1990s, new megaplexes had replaced most of Tacoma's historic neighborhood theaters. Some were destroyed, while others were converted into other businesses. The reintroduction of the original Blue Mouse, therefore, caused as much local excitement as the opening of the original theater in 1923. The new owners even held an open house before the opening, inviting those present to record the movies they would like to see at their neighborhood theater. By 1998, the Blue Mouse was a permanent fixture once again in the Proctor District. When the building celebrated its 75th anniversary that year, photographer Russ Carmack from the *News Tribune* documented the event. In this interior view, theater manager Sue Kendall is shown on the right. Patricia Rapozo stands behind the counter; on the wall above her is the clock from the Proctor Steak House. The Blue Mouse is now home to a variety of special events, including the Sister Cities International Film and Food Festival.

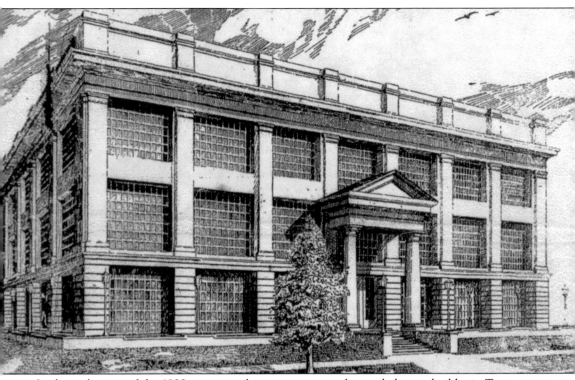

In the early years of the 1900s, municipal government was the single largest builder in Tacoma. It spent hundreds of thousands of dollars on such projects as roads, bridges, and substations. This 1924 architect's drawing depicts the Cushman substation, located on North Nineteenth Street between Washington and Adams Streets in the Proctor neighborhood. In 1925, a reporter for the *Tacoma Sunday Ledger* called it "a model of modern electrical engineering in a concrete structure of splendid exterior architectural design." The building served as the Tacoma terminal for power generated at the Cushman Lake hydroelectric power project originating on the Skokomish River in Mason County. Here the power entering the city at 100,000 volts was decreased to lower the voltage for distribution purposes. "A cool half-million dollars" would be spent, reported the newspaper, on the North End substation and its "transformer, lighting arresters, switches, and other electrical devices." Contractors Dugan and Chrisman completed the reinforced concrete building in 12 months.

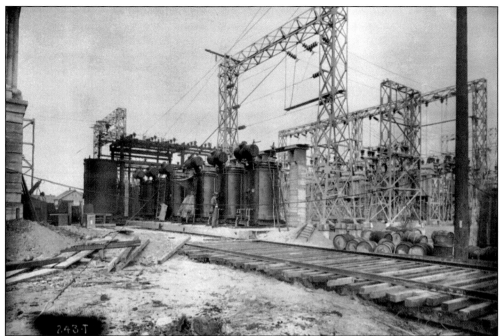

As seen in these 1924 construction photographs, the Cushman substation was plunked right down in the middle of a residential neighborhood. In 1927, after the facility was completed, neighbors brought a superior court suit against the city. While the court did not award damages for the alleged "unsightliness" of the substation, it did award damages for the humming noise created by the plant. The city appealed the decision to the Washington State Supreme Court. Superintendent Llewellyn Evans of the Tacoma Power Light Division proposed the creative solution of installing an ornamental fence, planting lawn and shrubs, and muffling the substation noise by covering the machinery with "a felt product in layers about an inch thick."

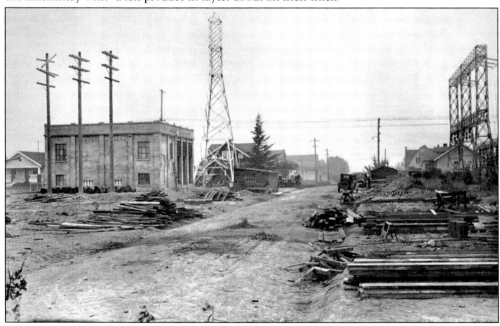

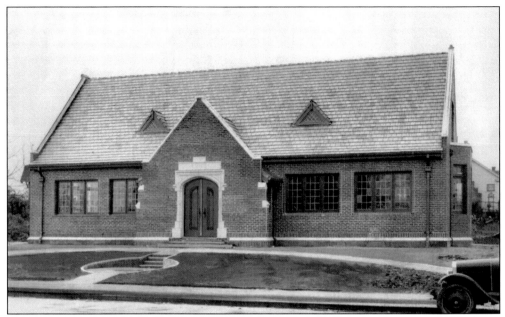

When the Carnegie Foundation failed to fund a library in the Proctor District in 1926, Anna E. McCormick came to the rescue by donating $25,000 for the English Tudor–style building completed the following year. Anna was the widow of Robert Laird McCormick, a prominent banker and lumber entrepreneur. Some 735 Proctor neighbors provided the $3,125 needed to purchase the land.

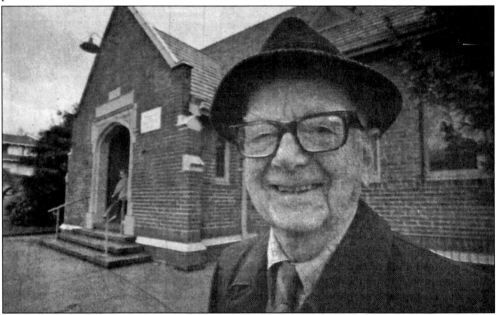

Silas Nelsen always wanted to be an architect. In 1917, after working for the Tacoma firm of Heath, Gove, and Bell for five years, he left to start his own firm. By the time of his death in 1987, he had designed numerous houses, at least 15 churches, many of the University of Puget Sound campus buildings, and three libraries in addition to McCormick. (Photograph by Jerry Buck, *Tacoma News Tribune*.)

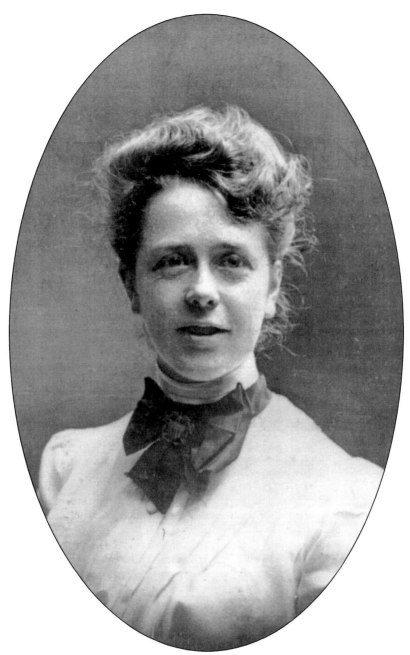

At the end of the 19th century, women had few opportunities for a professional career. Being a teacher or a librarian was, however, a solid option. Jacqueline Noel, born in Washington, D.C., in 1886, decided to become a librarian and not to marry. She began work at the Tacoma Public Library in 1914, rising from a position as an assistant in the reference department to city librarian by 1924. Jacqueline, shown here in 1910, was the force behind the creation of branch libraries in Tacoma; one can only imagine the meetings and discussions to convince neighborhood residents to donate the needed funds. By the time she retired in 1947, Proctor's McCormick branch library was growing, and by the time Jacqueline Noel died in 1964, many more branches were serving the city.

When the McCormick Library celebrated its 20th anniversary in 1947, the *Tacoma Sunday Ledger and News Tribune* celebrated the structure as "one of the most popular and used buildings in the community." Children were the primary users of the facility, the heaviest time being during the Depression. Charlotte Bergoust served as head librarian of the McCormick branch from 1928 to 1952 during this period of growth. Also an accomplished cellist, she played in the Tacoma Philharmonic and Tacoma Symphony Orchestras. Beginning in 1958, additions and interior changes were made to keep up with the increasing demands of library users. After a 1984 bond issue, the McCormick branch was given a new wing for library services and the old library was converted into a meeting space. The library acquired a new name in 1995, when Virginia Lemon Wheelock Marshall bequeathed $2.4 million to the Tacoma Public Library, provided that the new North End facility be named to honor her mother, Anna Lemon Wheelock. (Photograph by Ron Karabaich.)

Five

CENTERS OF LEARNING

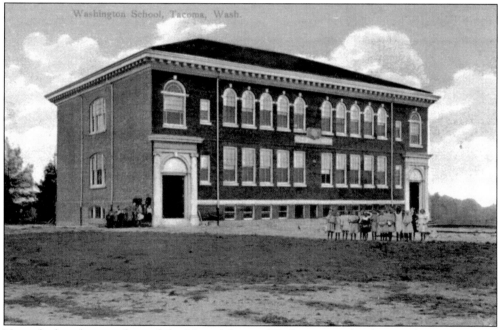

Named after the president of the United States, Washington School opened in a two-room schoolhouse in 1901. Principal Carrie Shaw Rice and Laura Ostrom were the first teachers. In 1897, Rice had become the first woman appointed to the Washington State Board of Education. Tacoma architect Frederick Heath was commissioned to design the new 1906 school, pictured here. Unfortunately, because another more-famous Heath design—today's Stadium High School—was dedicated the same day in September, Washington received little press attention. About the only thing mentioned was that surplus construction material from the high school was used in the Washington building. Even so, it is the oldest operating elementary school in Tacoma and one of the oldest non-residential buildings in the Proctor District. (Stenger collection.)

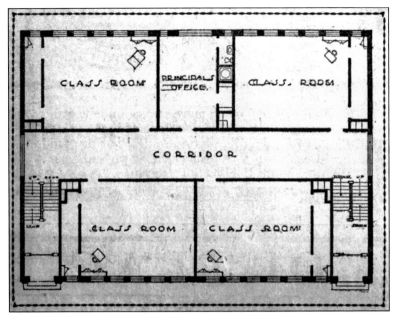

Washington was the first school in Tacoma to be built using the eight room–unit school design that was becoming a popular floor plan for public schools throughout the nation. Heath also created the building to accommodate growth. Above, his plan shows the interior spaces of four classrooms per floor for both the first and second stories. The basement served as a winter play area for the children. The windows were located on the outside walls of the building, and desks were to be arranged so that the light would fall on the pupil's work "over the left shoulder when seated." When additional space was needed, Heath proposed two wings connected perpendicular to the main school building, seen below. Of course, the wings were not constructed that way; nevertheless, it is interesting to note that school planners did think of future expansion at the time.

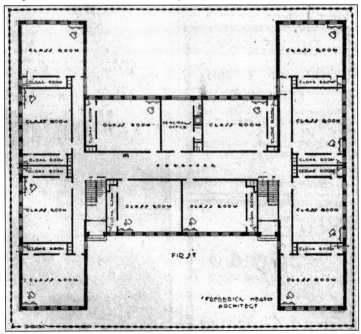

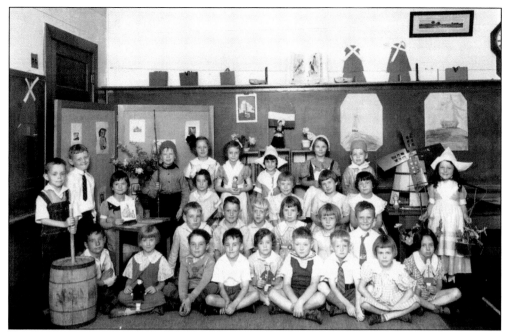

Many old-timers can remember those past school days when children dressed the part for the cultures they were learning and created artifacts representative of other countries. Wooden shoes and windmills decorate the walls in this 1934 Richards Studio photograph while the first graders display the results of their study of Holland.

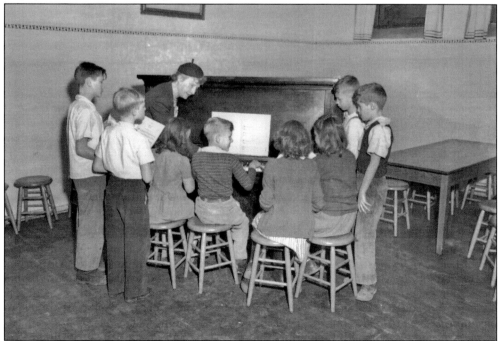

In this 1945 Chapin Bowen photograph, Washington School students gather around the piano. Note the teacher sporting a beret during the course of instruction. Perhaps the children are preparing for a recital celebrating the end of World War II.

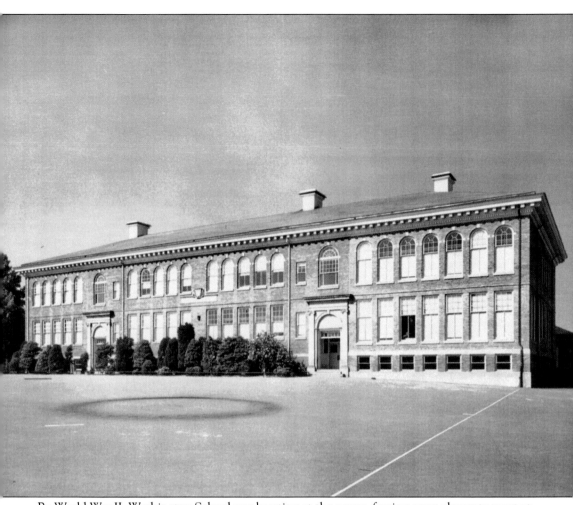

By World War II, Washington School was bursting at the seams, forcing some classes to meet at the Mason Methodist Church and the McCormick Library. By 1947, however, one new wing had been added to the south end of the building and the playground had been paved. The school's PTA sponsored a community campaign to fund the project, and the Kiwanis Club—along with Proctor merchants and other neighbors—raised the $4,000 needed to cover some of the $10,000 expenses for the new playground. Superintendent of schools Howard Goold told the crowd at its dedication ceremony that this was "the first instance in the city whereby a community had ganged up to finance a major improvement on public school grounds themselves." Within two years, the north end addition was completed. This 1949 Richards Studio photograph shows the school at that time, a view still familiar to Proctor residents today.

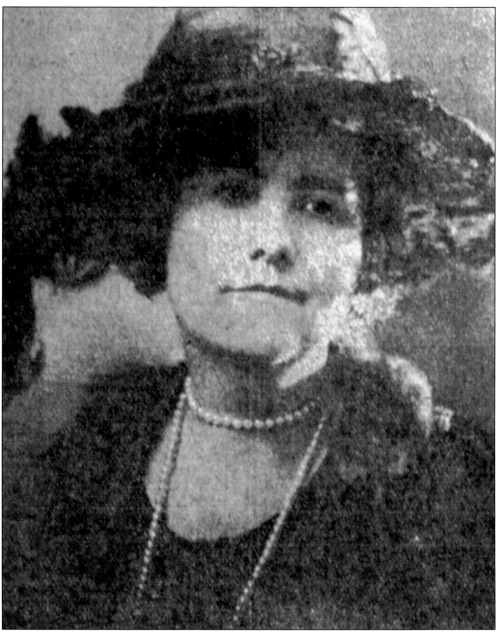

Washington's first principal, Carrie Shaw Rice, was raised and educated in Illinois, where she met and married John Franklin Rice in 1885. They were wed only three years when John died. Carrie moved west several years later and lived in Tacoma for 43 years. In 1894, Gov. John R. Rogers appointed her to the Washington Board of Education, making her the first woman in the state to perform the role. Except for a sabbatical in 1907, when she traveled to China and organized the first women's club in Hong Kong, she remained at Washington School from its beginning in 1901 until 1912. Carrie taught in Utah (1915) and California (1919) after that time, but always thought of Tacoma as home. Indeed, when Stadium Bowl was dedicated in 1910, one thousand schoolchildren sang "Tacoma: The Rose of the West," a song she wrote with Ophelia Baker Opie. Carrie died in 1926 at the age of 64.

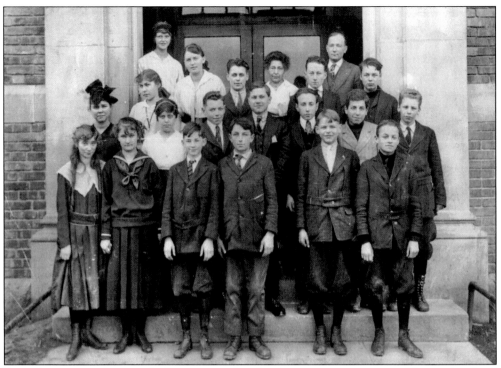

From the moment photography became popular, the class portrait was a part of the yearly school ritual. Everyone no doubt remembers the day when mothers made sure their sons and daughters were properly attired and the teachers worried lest the class clown ruin the image. These two photographs show the results at Washington School. Above is part of the 1917 class. All are unidentified except for Old Tacoma's Andrew Tadich, fourth from the left in the first row. A Richards Studio photographer captured one section of the 1927 sixth-grade class, shown below. The older woman on the left is believed to be Principal Jennie French.

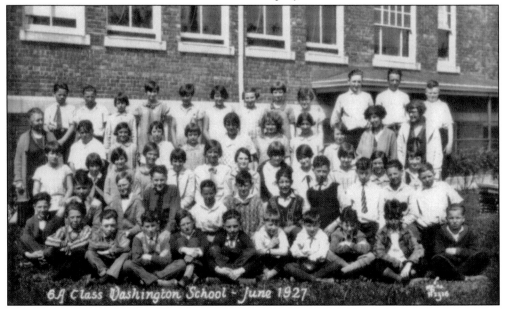

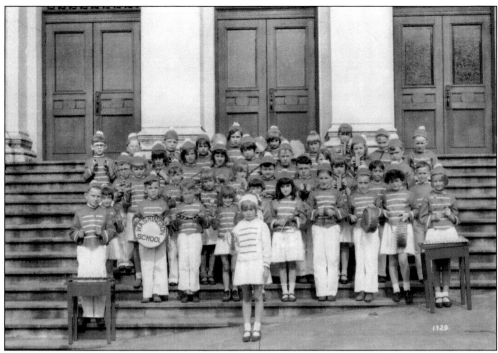

Class recitals or revues were also a part of the grade-school ritual. Parents would sit anxiously in the audience, watching their children dance, sing, and otherwise perform whatever the teachers had devised for the yearly program. In 1930, the Washington School Rhythm Band, pictured above in a Chapin Bowen photograph, might have been part of the program. Members pose in front of Tacoma's Scottish Rite Temple near Wright Park. Judging by the group of Washington fourth graders in front of the school below, tap dancing was part of the program in 1931. (Richards Studio.)

These five Washington School students were members of a group called the "100 Percent Pupils." Photographed by Chapin Bowen in 1931, the children probably received the title because of their perfect attendance. Their eyes of wonderment hide the economic realities of the Depression that undoubtedly made it hard for parents to send their children to school.

Before the days of hall lockers, there were cloakrooms. Washington's looked like this when photographer Chapin Bowen wandered in on November 9, 1945, to capture a rare interior view of the school. Why he took the image is unknown, but shortly thereafter the Tacoma School District Board began planning for Washington's new additions.

Women educators were a primary force during the early years of Washington School. Besides Carrie Rice, Jennie M. French served as principal from 1926 until 1941. Beginning her teaching career in 1908, she had been Point Defiance School principal before her arrival at Washington. On the day school opened in 1936, Jennie French posed with three Washington students for a Richards Studio photographer. While the unidentified lad on the left probably wanted to take his dog to class, Jennie said no. Prior to her death in 1957, she donated the site for Tahoma Terrace, a home for retired teachers.

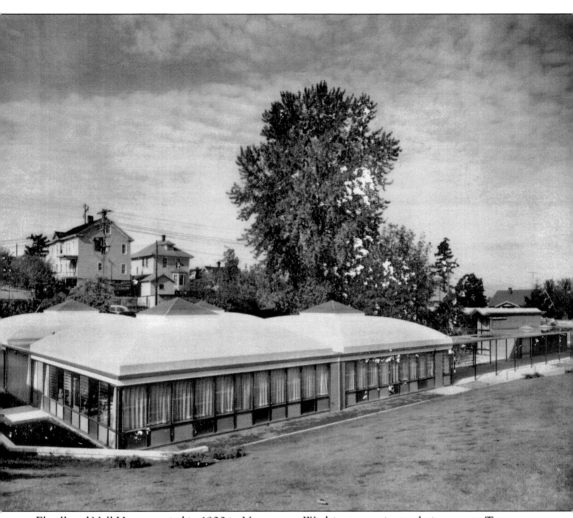

Elwell and Nell Hoyt married in 1900 in Vancouver, Washington, prior to their move to Tacoma. Nell began as a rural schoolteacher and, by 1911, had become the first president of the Tacoma Officers' Council of the PTA. In 1914, she worked to establish an organization patterned after the PTA but focused specifically on the needs of the very young. While her husband served as president of the Tacoma School District Board for eight years, Nell lectured about her concept of "pre-school" education, a phrase she coined in 1917. This concept assumed greater importance when endorsed by the national PTA. To honor her efforts, the new annex to Washington School at 2708 North Union Street, shown here in 1959, was named the Nell Hoyt School. She thought that her accomplishments were not worth the honor and that the school should be named instead for her husband. (Richards Studio.)

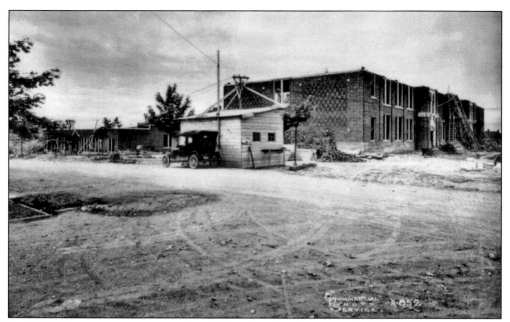

In 1923, Tacoma voters approved a $2.4-million bond issue to build six new intermediate schools. The Proctor District site was named to honor Allen C. Mason. The architectural firm of Hill and Mock designed the building, located at 2812 North Madison Street. It is under construction in this 1925 view. E. H. Butler, then the head of Washington School, was Mason's first principal. On opening day, the student body numbered 437 from surrounding elementary schools. (Richards Studio.)

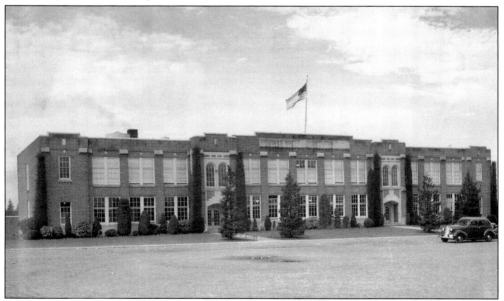

Originally, Mason School sat far back on the lot, and it was not until the 1950s that more land was needed and acquired for additional schoolroom space. In 1940, the building was a monumental presence in the neighborhood, noted specifically for its playfield that seven years before was called the largest in the city outside Stadium Bowl. Situated to the west of the school and extending to North Mason Street, the grounds were completed in 1933. (Richards Studio.)

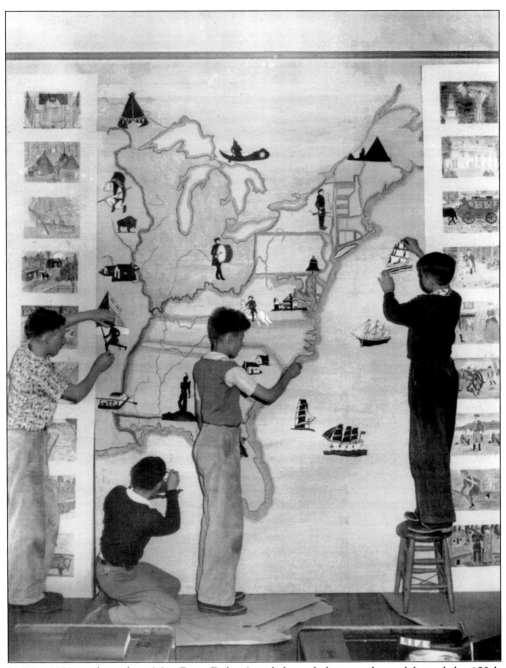

In May 1939, students from Miss Zetta Dalton's eighth-grade history class celebrated the 150th anniversary of the U.S. Constitution by creating a large graphic map of the country as it appeared in 1789. The map was then used as the background for three historical skits enacted by the students. Pictured from left to right are Alan McLean, Jimmie Davis, Bob Winskill, and Kenny Burrows. (Richards Studio.)

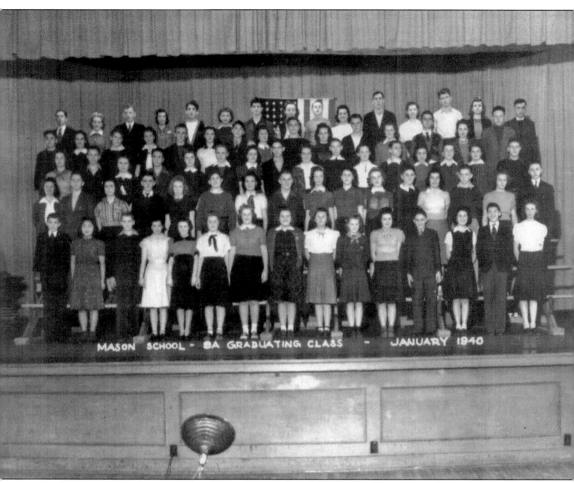

MASON SCHOOL - 9A GRADUATING CLASS - JANUARY 1940

In January 1940, Mason School graduating class 9A gathered on risers placed in the school auditorium while a Richards Studio photographer took a group portrait. Times were good for these youngsters. A short walk down North Proctor Street led to ice cream parlors, and cool band music could be heard on the radio.

As class sizes got larger, it became more difficult to capture all the students attending one school—or even one grade. The challenge was solved through the introduction of panoramic photography, as evidenced by this June 1942 Mason Junior High School class portrait. Anita Oliver, Ernie Klarich, Jeanne Miles, Leon Clark, Paul Krilich, Kenneth Moe, Jane Hagen, Shirley Jackson,

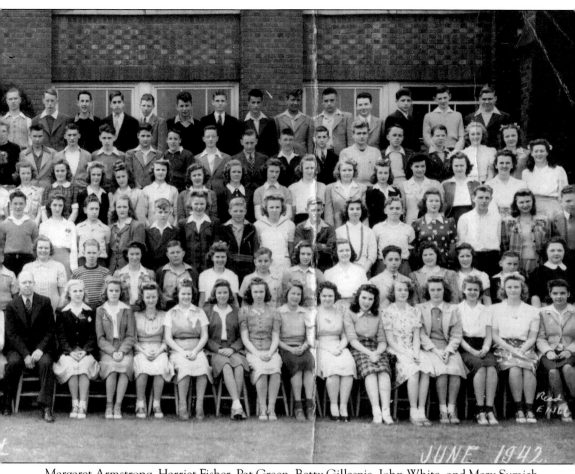

JUNE 1942.

Margaret Armstrong, Harriet Fisher, Pat Green, Betty Gillespie, John White, and Mary Sumich are some of the students who autographed the reverse side. A Read Photo Service photographer took the image using the school building as his backdrop.

Mason Junior High School's Bernice Hawley was one of the Tacoma School District's first English as a Second Language teachers. She is pictured at Mason in January 1949 with three of her international students: Fan Eng (left) from near Canton, China, and sisters Turrid (center) and Bodil from Stavanger, Norway. (Richards Studio.)

On March 30, 1950, the Mason Junior High School PTA sponsored a talent revue that included these young women performing the Slavonic dance from *Nutcracker Suite*. The ballerinas are, from left to right, Gail Baden, Carolyn Solberg, Jilleen Cormier, Kaydene Anderson, and Mary Lee Thompson. (Richards Studio.)

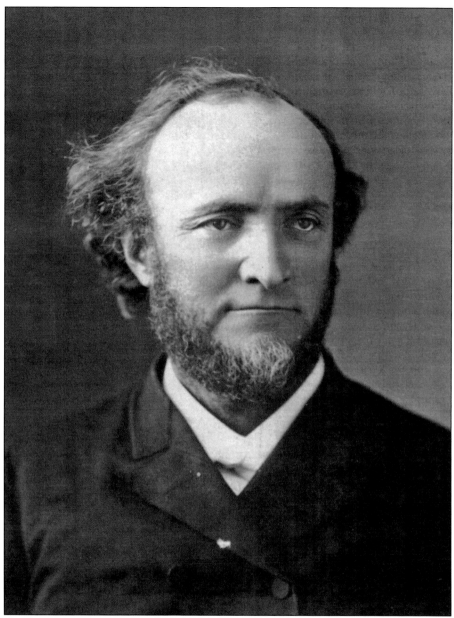

Bishop Charles Fowler, former president of Northwestern University, presided over the first Puget Sound Conference of the Methodist Episcopal Church, held in Tacoma in 1884. His dream was to found a great educational institution on the shores of Puget Sound. The conference endorsed his idea, but then came the difficult task of choosing a site. In 1887, a group of enthusiasts tried to "steal away" the university to Port Townsend by promising money and land. A bitter rivalry ensued, but through the labors of Dr. David LeSourd, Puget Sound University was incorporated in Tacoma on March 17, 1888. There were 88 students enrolled for the 1890–1891 academic year. Tuition was $15 for the preparatory school and $20 for the college. In 1893, local supporters suggested that a new town, named University Place, would be the ideal site for the school, while others insisted on a campus in Tacoma. The institution experienced great financial difficulties until it was reorganized as the University of Puget Sound in 1903.

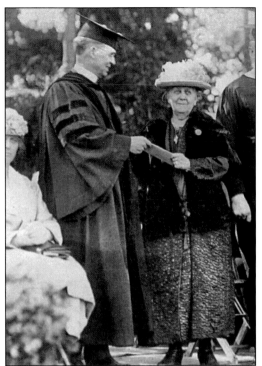

In the 1920s university trustees decided to build a new campus for the growing student body. Tobey Jones, shown here in 1923, donated $180,000 to help fund the first building. Receiving the check is college president Dr. Edward Todd. The structure was named Jones Hall to honor Tobey's husband, Charles H. Jones, one of the founders of the St. Paul and Tacoma Lumber Company.

The cornerstone for Jones Hall was laid on February 22, 1924. Doing the honors are Tobey Jones (left); D. D. Brown (center), also present when the cornerstone was laid at the school's first location (near today's Jason Lee Intermediate School); and Dr. David LeSourd, one of the original incorporators of the college in 1888. (Photograph by Marvin Boland.)

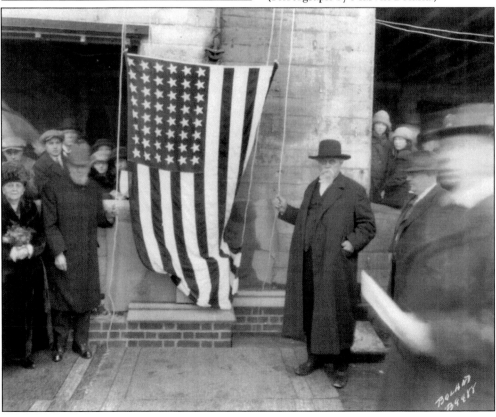

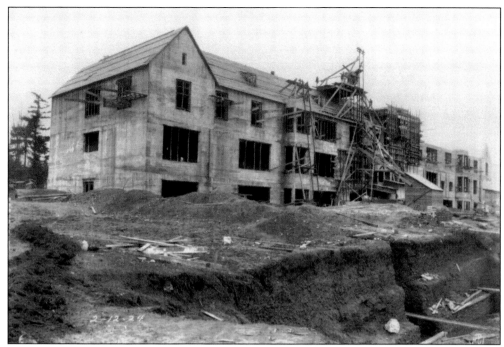

The architectural firm of Sutton, Whitney, and Dugan designed the entire "new" campus of the College of Puget Sound, located at North Fifteenth and Warner Streets. The campus was to be patterned after Cambridge University in England, with Jones Hall the first part of a broader plan. Classes were first held in the completed building in the fall of 1924. (Photograph by Marvin Boland.)

When the building designs were published in the *Tacoma News Tribune* in April 1924, the open, landscaped space on the east side of Jones Hall was to be called Sutton Quadrangle (above) to honor the late Albert Sutton, the original architect for the college. The Science Building (below) was to be rushed to completion by the beginning of the 1924 academic year.

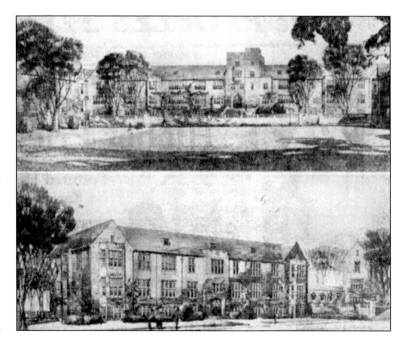

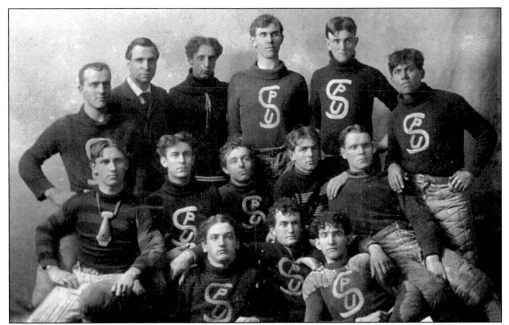

Football has been a part of campus life since the founding of the university. In 1902, when the college was called Puget Sound University, players posed for a group portrait wearing their PSU logos on their jerseys. Many seen here continued on, undefeated, in 1903.

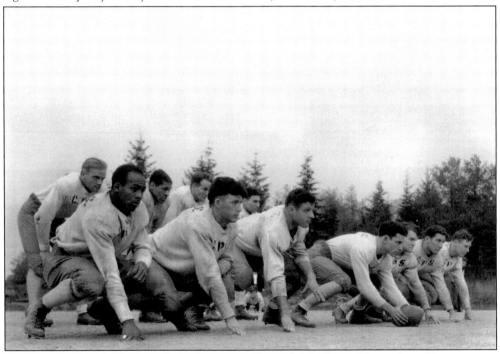

In 1933, under the leadership of Coach Roy Sandberg, the College of Puget Sound Loggers won the Northwest Conference Football Championship for the first time in the school's history. Here a Richards Studio photographer recorded the 1934 team, which also went on to win the conference title.

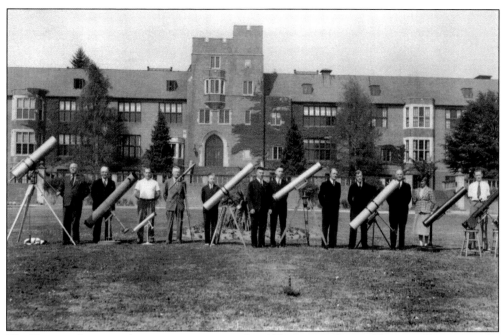

The Tacoma Amateur Astronomers, organized in 1931, pose in front of Jones Hall in 1939. The photograph was exhibited in the Planetarium at the New York World's Fair, where over 44 million people could see it. The fair, whose theme was "The World of Tomorrow," focused on interplanetary travel, the computer, and a new invention called the television. (Richards Studio.)

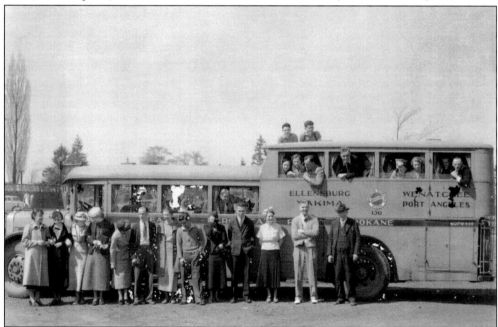

The university was conceived as a liberal arts college, and because of this, a wide array of activities was presented to the students to assure a well-rounded education. On March 21, 1935, members of the Adelphian Choral Society pose in and around the double-decker bus that will take the singers on a 19-day trip to engagements in 22 eastern Washington communities. (Richards Studio.)

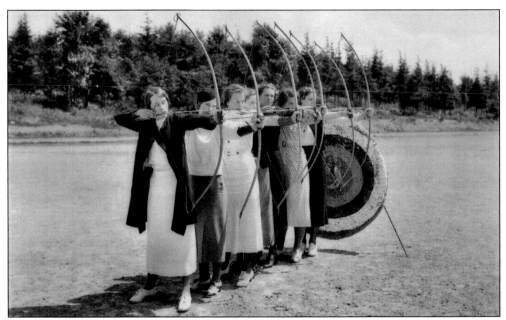

In May 1934, the annual women's intramural archery tournament was held at the College of Puget Sound. Contestants shot 12 arrows each from 30, 40, and 50 yards. Loggers participating in the contest were, from left to right, Loretta Altman, Geneva Kenway, Harriet Giske, Berenice Hanson, Sylvia Asp, June Shinkle, and Brunhilde Wislicenus. Vonne Prather, not pictured, was the overall winner. (Richards Studio.)

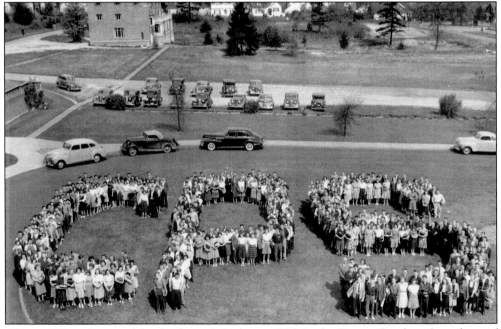

Almost 500 students and faculty formed the letters CPS in the Sutton Quadrangle in front of Jones Hall in 1940. In 1903, the school was called the University of Puget Sound. Then from 1914 until 1959, it was the College of Puget Sound. In 1960, the college regained its earlier name and has retained it ever since. (Richards Studio.)

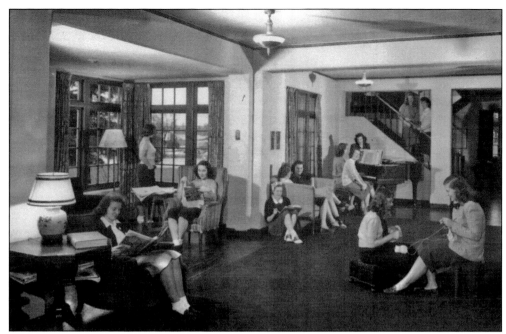

This 1948 Richards Studio photograph (as well as the one below) provides an idealized portrait of dormitory life midway through the 20th century. The women are reading and knitting. One is perhaps playing the piano. The serene atmosphere provides no hint that within a few short years the women's liberation movement would change the nature of campus life far into the future.

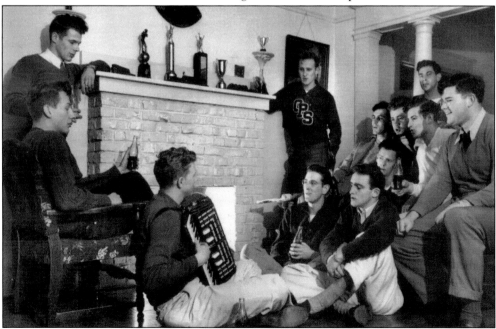

Meanwhile, in the men's dorm the same year, the gents have gathered around an accordion player, apparently singing to the tune while drinking their Coca Colas. Logs burn in a fireplace topped by sports trophies. Within two years, some of these men might be in the military fighting in the Korean War. (Richards Studio.)

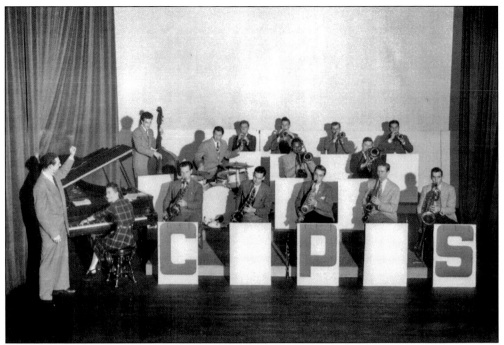

A musician, composer, and jazz writer, Leroy Ostransky enlivened Tacomans. By 1947, he had organized the Workshop Band at the College of Puget Sound as an extracurricular activity. Members would play jazz arrangements written in one of Ostransky's classes. In this Richards Studio photograph, taken for the *Tamanawas* yearbook, the band performs while Leroy conducts stage right.

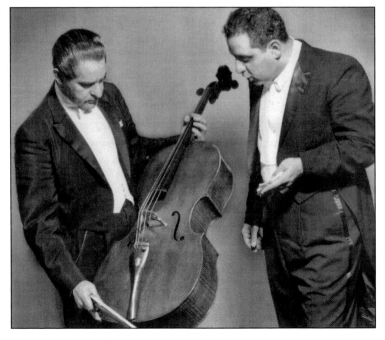

Conductor and Julliard School of Music violinist Edward Seferian was another university gift to the city. He created and conducted the Tacoma Symphony Orchestra, which still survives today. Seferian is shown on the left with an unidentified cellist as part of an article published in the *Tacoma News Tribune* advertising the 1965–1966 Tacoma Symphony season. (Richards Studio.)

Six

PROCTOR PEOPLE

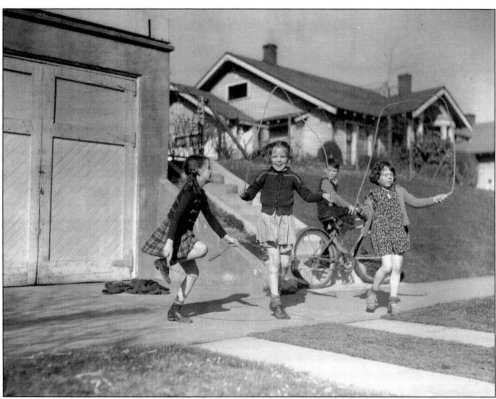

The Proctor District has always been alive with people, something that is rarely understood in the street views of buildings. Old-timers remember the ethnic mix present in the neighborhood and the many children walking to and from Washington Elementary and Mason Intermediate Schools. Both these educational institutions, along with district business owners, initiated projects and events—parades and parties—that placed young people at the center of community life. In 1939, a Richards Studio photographer captured Washington students for a feature in the *Tacoma Times*. Charlotte Ann Nelson (left), Beverly Grace Richardson (center), and Grace Loudin skip rope. A 12-year-old Billy Myers poses on his bicycle behind the girls, probably watching the photographer more than his playmates. The view was taken on North Twenty-seventh Street just across from Washington School.

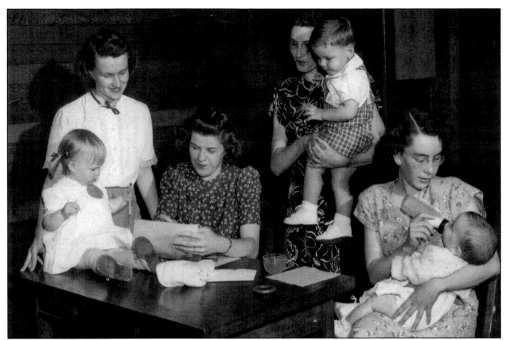

Families in post–World War II America launched a baby boom that produced the so-called "Yuppie" generation as the children reached adulthood. The Proctor District played its roll in the population explosion, with the Mason Methodist Church sponsoring a Young Married Couples Club. One of the organization's activities was a Baby Show held in the church gymnasium. Above, three unidentified mothers register for the May 1948 event. Below, the contestants pose in a group portrait. Myrna Miller, Harry Burns, and Rev. J. Henry Ernst were to judge the babies on their "most surprising characteristics." According to the *Tacoma Times*, "Special gifts would be awarded to the contest winners, and all participants would receive baby gifts." (Richards Studio.)

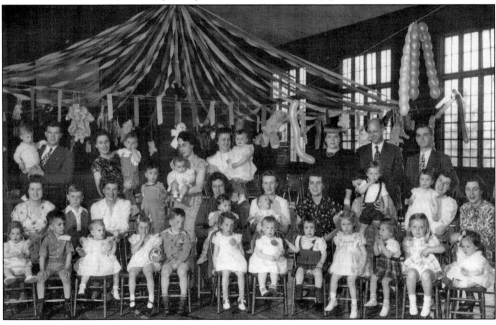

Proctor District children were encouraged to read and to use the McCormick branch of the Tacoma Public Library. In this 1956 image, library director Howard M. Row looks on while youngsters are introduced to a new machine that stamps the due date. Neither the children nor the librarians are identified. (Richards Studio.)

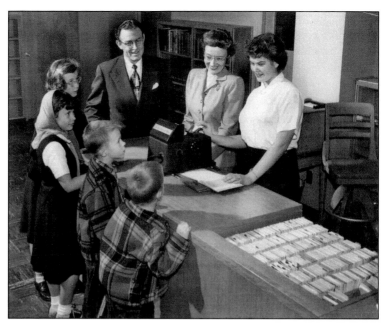

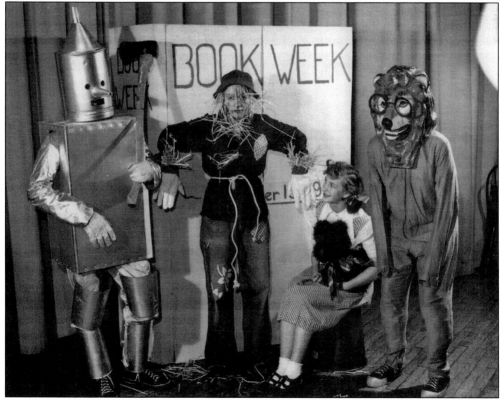

For Bookweek in 1948, Mason Junior High School held an assembly during which students presented skits based on their favorite works. One portrayed the main characters from the *Wizard of Oz* with, from left to right, Roy Wright as the Tin Man, Gwen Collier as the Scarecrow, Phyllis Carman as Dorothy, and Warren Brown as the Cowardly Lion. (Richards Studio.)

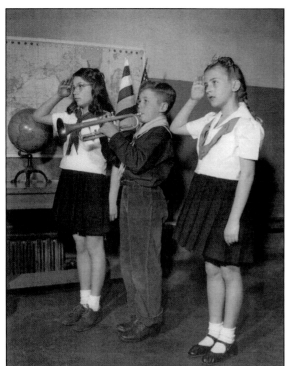

As diplomats gathered in April 1945 to form the United Nations, youth organizations nationwide participated in ceremonies designed to encourage students to determine their future role in maintaining world peace. At Washington School, part of the ceremony included Patsy Phillips (left), Ronnie Schermerhorn (center), and Judy McMillan performing a salute to the American flag. (Richards Studio.)

The Mason Methodist Church was home to a group of Campfire Girls in the post–World War II years. At their Fire Maker Tea in 1948, the young women honored Mrs. Charles Mason (not shown) for introducing them to opera and Pansy D. Whitehead, founder of the Tacoma Story League. Here Pansy tells the story of *Hansel and Gretel*. (Richards Studio.)

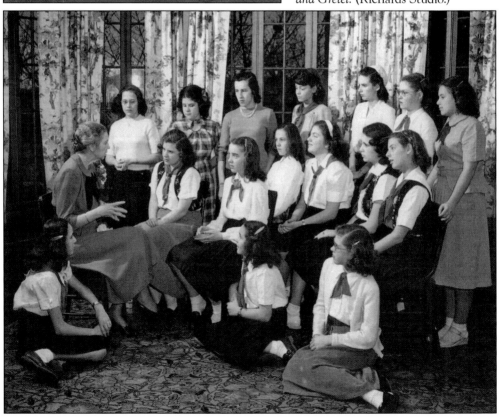

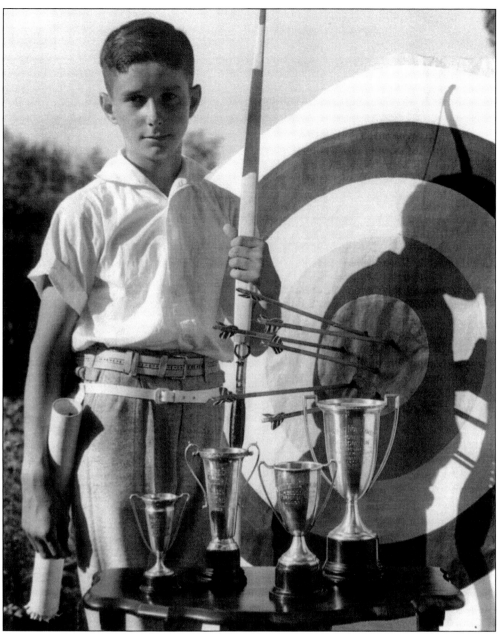

Sports, recreation, and play have been a part of the Proctor District ever since Allen C. Mason donated Puget Park to the city in 1889. And while most people tend to link sports to the traditional activities of football, baseball, basketball, and track, Sonny Johns (pictured in 1938) demonstrates that a sports champion can achieve notoriety with a bow and arrow. Sonny and his parents lived on North Twenty-seventh Street, west of the Proctor commercial district, but close enough for the community to accept him as one of its own. During the year of this Richards Studio photograph, the 13-year-old Sonny had just become Washington Junior Archery Champion. With the help of donations from the Tacoma Chamber of Commerce, he went on to win the Northwest Junior Championship in Portland, Oregon. While there, he shot three "perfects," a feat that had not been achieved in any previous world competitions.

During the 1930s, educational programs at Washington School—like many in the country—went beyond the rudiments of reading, writing, and arithmetic. While traditional sports for boys were an accepted curricular activity, girls were presented with alternatives to the rough and tumble of the playground. Dance was one such option, as evidenced by this c. 1930 Chapin Bowen photograph.

Depression-era schoolchildren citywide launched a Thanksgiving food drive in 1937. The students at Washington School decided to display what they had collected prior to their distribution to the needy. Seen here from left to right are Janice Johnson, Juanita Evans, Ramond Demorest, Richard Howsen, and Robert Sinclair. (Richards Studio.)

North End schoolchildren also helped with the annual March of Dimes fund-raising campaign. Pictured in 1951 from left to right are Tommy Fishburn, Rodney Anderson, Teddy Durin, and Kenny Durin as they man the collection table at North Twenty-sixth and Proctor Streets. Tables had been set up all over Tacoma, but Proctor's got more press because Rodney Anderson was the son of Mayor John Anderson. (Richards Studio.)

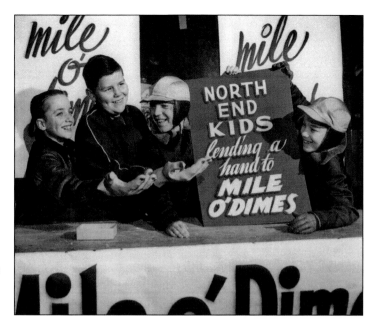

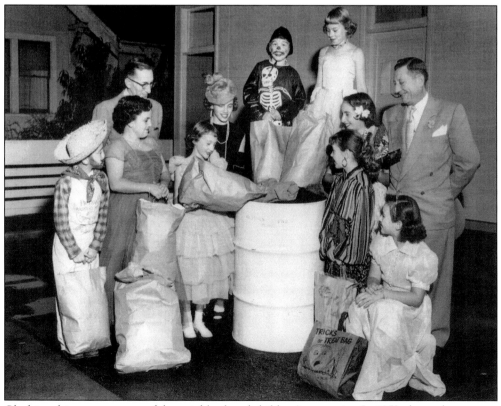

Clothing drives were a part of the neighborhood children's repertoire. In 1953, the goal was warm clothes for the needy in South Korea, a project sponsored by the Overseas Relief Committee of the Tacoma Council of Churches. The effort was related to the brutal war between North and South Korea, the United Nations, and China. (Richards Studio.)

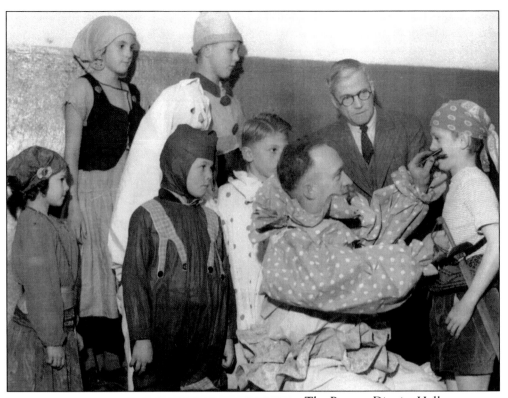

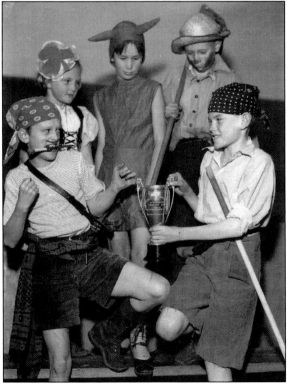

The Proctor District Halloween Party, held for all North End residents, was repeated for the seventh time in 1935 with Mayor Smitley, the American Legion Drum and Bugle Corps, and a bonfire at Mason playground. Above, an unidentified clown creates a painted moustache on Lyman Burke of Washington School. At left, Lyman (left) and John Hughes of Jefferson School hold the Attendance Trophy Cup awarded to the school with the most people at the event. Behind the two boys are Marilyn Wagnild (left), also from Jefferson School, and Betty Jean Woley (center) and Edward Miller, both from Point Defiance School. Today's Proctor Treats continues the tradition. (Richards Studio.)

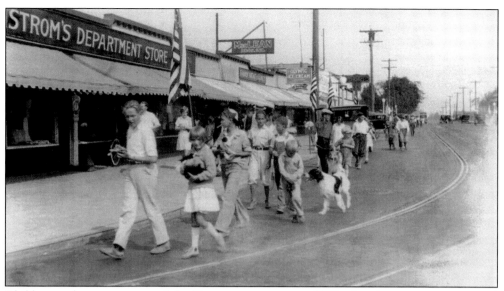

Children and pets were part of the Proctor streetscape in 1928, when businessmen sponsored the second annual parade held for the children by the Tacoma Playground Department. Above, the Pet Parade marches along North Twenty-sixth Street past Sanstrom's department store on the corner of North Proctor. Below, those featured in the August 26 *Tacoma Sunday Ledger* are, from left to right, (first row) Billy Dimock, Charles Mason with his tortoise, and Ellis McLean with Tiny, his Boston terrier; (second row) Henry Johnson, Harry Friberg, Jack Murphy, Harry Ruvo, and Helen Blatt with Billy Buck, her white rabbit.

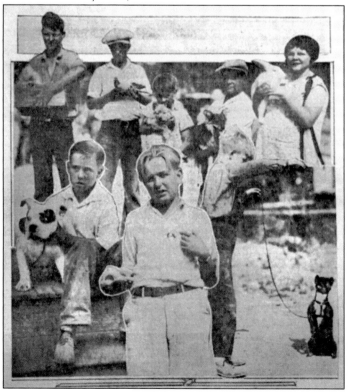

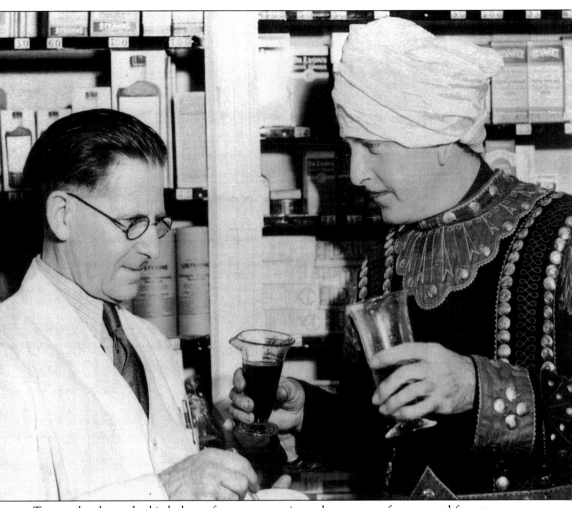

Tacoma has been the birthplace of many entertainers, but none as funny—and forgotten—as Yogi Yorgesson, pictured here in 1936. Yogi was the stage name of Harry Edward Stewart, born in 1908 and adopted following the death of his mother, Elise Skarbo. Harry attended Washington Elementary and Stadium High Schools before starting his radio career in 1927 at Tacoma's KVI. He then created a persona—the Hindu mystic from Stockholm, Sweden—that delighted radio and live audiences worldwide until his death in 1956. Yogi's jokes were corny by today's standards, but the act may have inspired Johnny Carson's swami on the *Tonight Show*. Stewart visited Tacoma quite often, performing at the Western Washington Fair in Puyallup and garnering publicity in the *Tacoma News Tribune*. In this Richards Studio photograph, Yogi presents his antics to an unidentified druggist.

By the 1950s, the Proctor District's Rosie the Riveters were back home caring for their war-boom babies. Among the many new tasks the women now performed was decorating and redecorating the house. Two unidentified neighborhood ladies ponder Dutch Boy paint samples at the Lang and Dennison Hardware store, located at 2618 North Proctor Street. (Richards Studio.)

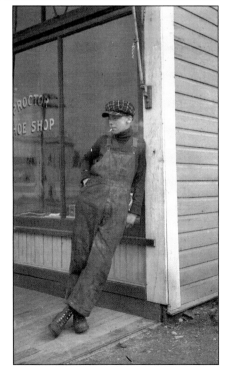

Very few photographs have been located that show Proctor's typical "man on the street," but this young unidentified gent posing outside the Proctor Shoe Shop provides one glimpse into the neighborhood's past. Perhaps he is waiting for the streetcar. The store stood on the north side of North Twenty-sixth Street.

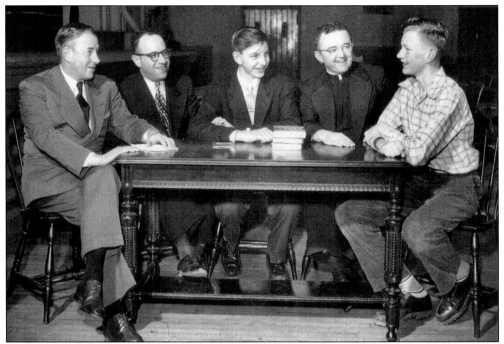

In the days before television, serious debates of world events occurred at school assemblies. At Mason Junior High in 1949, one such gathering was a roundtable discussion climaxing Brotherhood Week. Participants, pictured from left to right, were Dr. Harold Long (Immanuel Presbyterian), Rabbi Bernard Rosenberg (Temple Beth Israel), Mason student Roy Wright, Fr. Henry Buchman (St. Patrick's), and Mason's Sumner Bennett. (Richards Studio.)

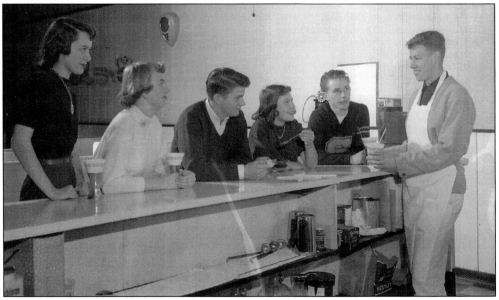

Many of today's old-timers think back nostalgically to their teenage years, before rock 'n' roll, when life was simple and hanging out with friends at the local malt shop was the primary source of entertainment. The Proctor Ice Creamery, at 3818 North Twenty-sixth Street, was one such place where the youth gathered in 1952. (Richards Studio.)

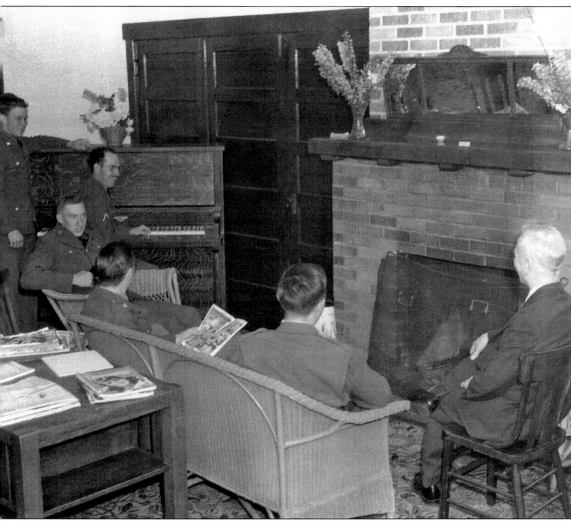

Tacoma's churches, including Methodist congregations, have always provided social services in times of crisis. During and after World War I, for example, the downtown First Methodist Episcopal Church near Tacoma General Hospital provided space for soldiers recovering from the 1918–1919 influenza pandemic. Methodists were also the driving force for seeing churches—like schools—as community centers for an entire neighborhood. In Tacoma, the denomination formed one of the city's first immigrant community centers and established Goodwill Industries. After the country entered World War II and Fort Lewis was saturated with soldiers, Tacoma found itself with a rooming shortage for those on weekend leave. Churches, including Mason Methodist, created dormitory space and a Sunday morning breakfast for those in need. Unidentified men gather around the church's Club Room fireplace in this June 1942 photograph. (Richards Studio.)

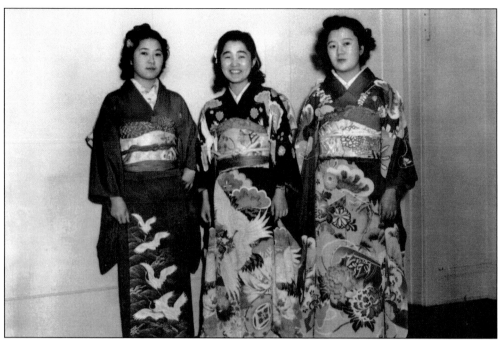

The Japanese were one of many ethnic and racial groups found in the Proctor District. Today a sidewalk marker honors Hachiro Takashima, who owned a shop in the neighborhood. The College of Puget Sound was a magnet for Asian students, as evidenced above. In the 1939 photograph, three coeds pose in traditional dress. There is a tinge of sadness to the image below. Dated May 1, 1941, the photograph shows College of Puget Sound Japanese students raising funds for the school's Student Union Building. The pictured grocer donated $10 and expressed a hope that his son standing next to him would attend the college. In less than a year, all of these people would be in an internment camp constructed within the fairgrounds in Puyallup. (Richards Studio.)

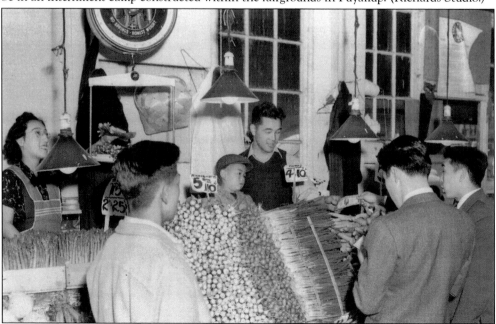

Seven

Other Stops
along the Way

From downtown, Allen C. Mason's streetcar skirted along the north end of Wright Park and turned onto North I and North Twenty-first Streets. At North Fife Street, the trolleys crossed the bridge he built across Buckley Gulch. Here, beginning in the 1890s, a small residential and commercial district began to form as a place where people gathered to catch a ride. A. Brosseau constructed a three-story wood-frame business block at 2716 North Twenty-first Street in 1907. Ohiser's Appliance store opened in the building in 1938 and remained in operation until 1996. At 2705 North Twenty-first Street, Cephus and Stella Latterell ran the Little Bob Shop in 1925. The same block also sported one of Tacoma's first neighborhood theaters—the Bungalow Photo-Play Theater—at 2701 North Twenty-first Street. Frank H. Beck and Cleo E. Henriot were the 1914 operators of the Bungalow Amusement Company. (Richards Studio.)

Some of Tacoma's oldest houses were constructed along North Twenty-first Street following the arrival of the streetcar. And many, while altered over time, still remain. The two shown here were built around 1890 and were photographed in 1977 as a part of the City of Tacoma's Cultural Resource Survey. F. F. Plowden purchased the house located at 2402 North Twenty-first Street (above) from Charles Curtiss in 1905. Curtiss also built the house at 2406 (below), which was occupied by Charles and Eunice Staples by 1903. Both were situated close to the east side of the Buckley Gulch Bridge.

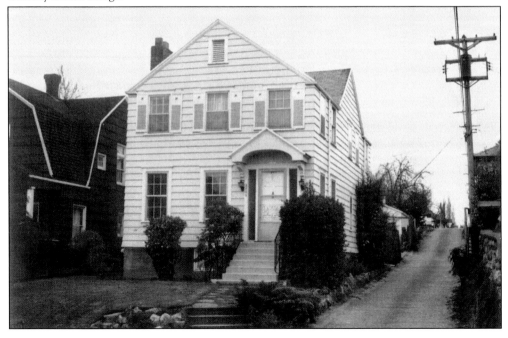

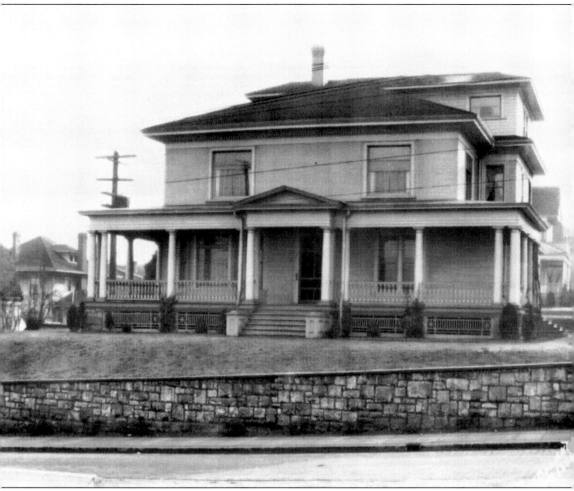

The street's most notable residents were John and Katherine Bagley, who by 1908 lived in this house at 2420 North Twenty-first Street. Tacoma architect George Bullard designed the residence for William T. Branch in 1904, and it was Branch whose Buckley addition named the gulch. John Bagley was eulogized at his death in 1920 as one of Tacoma's major builders whose great achievement was the construction of the Tacoma Eastern Railroad, running from the city toward Eatonville, Elbe, and Ashford. Before his death, Bagley had converted the house into apartments, and by 1929, James and Ella Newbegin were its residents. James served for a year as Tacoma's mayor following the resignation of Melvin Tennent. Marvin Boland photographed the house in 1928 just as this event was unfolding. The house, which still stands, had become the Don Mar Apartments by the 1960s.

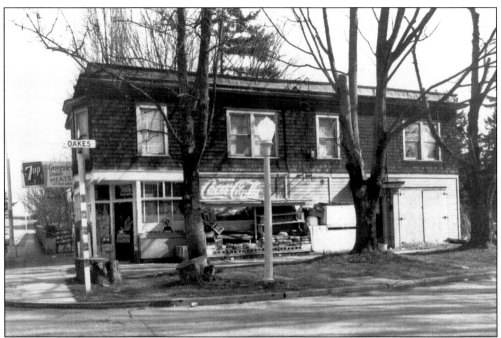

The first known commercial development on the west side of Buckley Gulch was Ella Healy's Store (above), built at 2624 North Twenty-first Street in 1904 and photographed by William Trueblood in 1969. The building's backside faced the gulch, where an unknown person constructed the Canyon Garage in 1909. A year later, the garage crashed to the bottom of the ravine, looking, according to the *Tacoma Daily Ledger*, as if a "cyclone had struck it." Architects Lundberg and Mahon designed the building below, across the street from Ella Healy, for Charles Henriot in 1914. The George Gill Drug Company and Dewey Crabb's Barber Shop were two of the first occupants. (Below, Tacoma Cultural Resource Survey, 1977.)

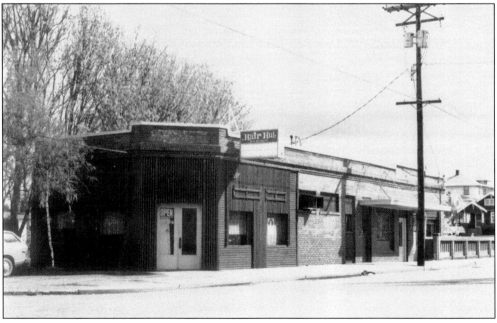

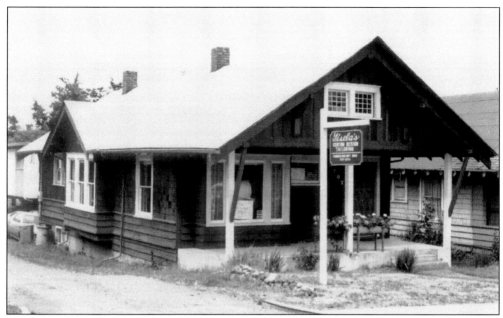

In 1908, Dr. E. W. Janes commissioned the architectural firm of Woodroffe and Constable to design this small, craftsman-style bungalow at 2707 North Twenty-first Street—probably for speculation, since within a few months a Mrs. H. Gamble bought it from him. For most of its life, it was undoubtedly a residence, but by 1977, when this photograph was taken, it had been converted into commercial use. (Tacoma Cultural Resource Survey.)

Prior to the 1920s, C. B. Latterell lived in a house on the corner of 2702 North Twenty-first Street and ran a barbershop out of it. By about 1926, he had constructed this building and, besides his barbershop, was providing commercial space for other businesses. Among them were the Chamberlain Meat Market and a Piggly Wiggly store. (Tacoma Cultural Resource Survey, 1977.)

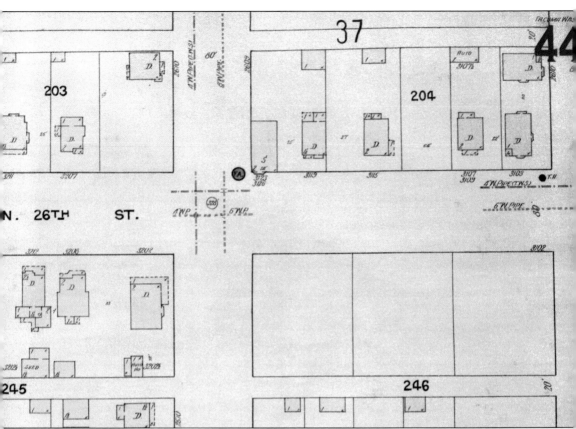

Once the trolleys left the Buckley Gulch stop, the route took them along North Twenty-first Street to North Alder Street, where a turn carried them to North Twenty-sixth Street. At that point, the route turned west toward the Proctor District. This early and undated Sanborn Insurance map shows the area at a time when only houses covered the landscape. A small commercial district did gradually emerge at the turn, however, as residents catching a ride became magnets for potential entrepreneurs. The first business to appear is unknown; perhaps it was the Monarch Drug Company, shown in the next photograph. Neither this nor the stop at Buckley Gulch ever reached the size of the Proctor District.

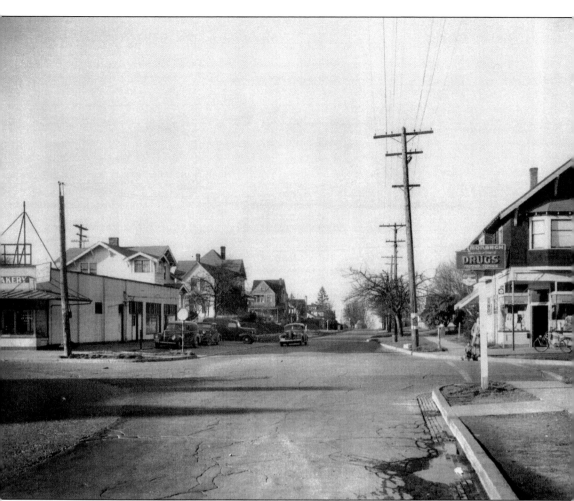

In 1947, a Richards Studio photographer pointed the camera north from the intersection of North Alder and Twenty-sixth Streets, showing the Alder Street Bakery on the left and the Monarch Drug Company on the right. Constructed in 1909, the latter building was first a store for a Mrs. C. P. Roberts, who probably lived upstairs. L. Clarke and Ethelwyn Hughes owned the Monarch Drug Company by 1936. The business advertised prescriptions, ice cream, candies, magazines, and tobacco. The houses seen in the background were built in the early years of the 20th century. Three known residents living along the 2600 block of North Alder were M. Place, Lulu Roberts, and Charles A. Briggs.

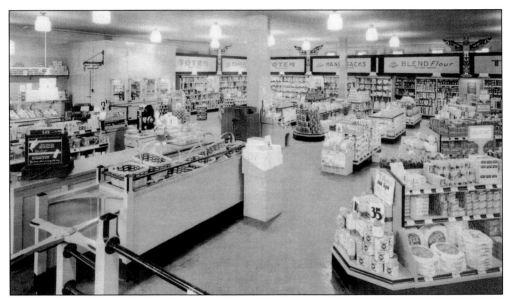

In December 1936, the *Tacoma Daily Ledger* announced the construction of a Totem Food store on North Alder Street. The arrival of Totem Food marked the entry of chain stores into the various districts formed by the streetcar and illustrated how business interests changed with the advent of the automobile. And the store was known for provisioning some of the local purse seine fishing boats. Above, photographer Chapin Bowen captures the Totem Food interior close to the time of its opening in April 1937. In January 1938, according to the *Tacoma Ledger*, local grocery stores and the Sperry Milling Company were "offering special prizes for the solving of 'Applegrams,' special anagrams." The Totem Market on North Alder contributed to the effort through the display pictured below. (Below, Richards Studio.)

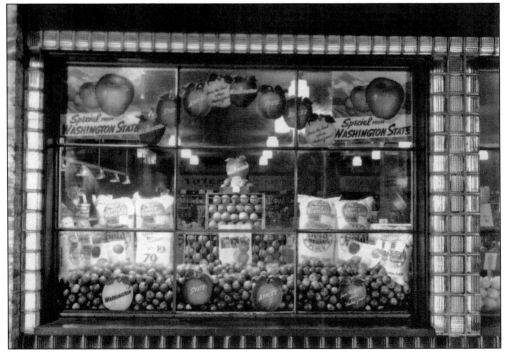

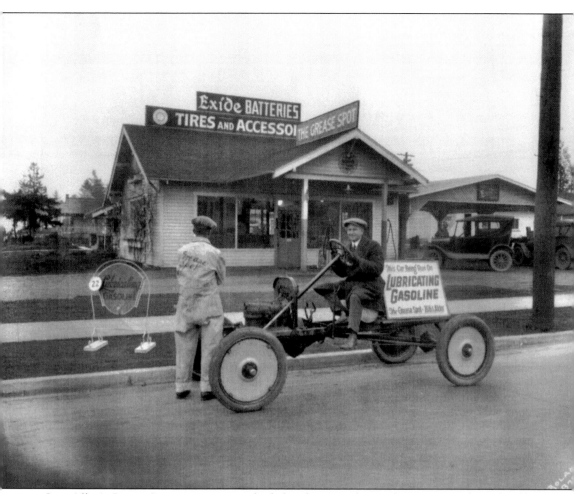

Sam Allen's Grease Spot service station had already sat on the southeast corner of North Alder and Twenty-sixth Streets for almost 15 years when Totem Foods opened for business. As shown here, the station was a simple, wood-framed (almost bungalow) affair with a side-open garage for repairs. "Why Use Water for Engine Cooling?" headlined the 1923 Marvin Boland photograph in the *Tacoma Daily Ledger*. Allen had driven around the city without a radiator using a lubricating gasoline. He had "made the experiment to convince skeptics that lubricating gasoline does create less friction in the motor, thereby giving better engine service and mileage." Gas pumps and a mini-market have now replaced the Grease Spot, but the former Totem Foods remains as a traditional neighborhood market.

The Alder Street Bakery, managed by Curt P. Rath in 1936, was one of the earliest businesses in the building at 3201 North Twenty-sixth Street. Besides the bakery, the Edward J. Holmes Market and the Paul Bullis Barber Shop also shared storefronts. The structure remains, as this recent Ron Karabaich photograph shows. No image survives showing the 1908 Allington and Martha Johnson house across the street. It was moved one block west in 1928 to make way for an Associated Oil Company service station. Allington Johnson, who managed the Allington Hotel downtown, explained at the time that no damage occurred during the move, which also required the temporary removal of streetcar lines. The house can be seen today on the northeast corner of North Twenty-sixth and Lawrence Streets.

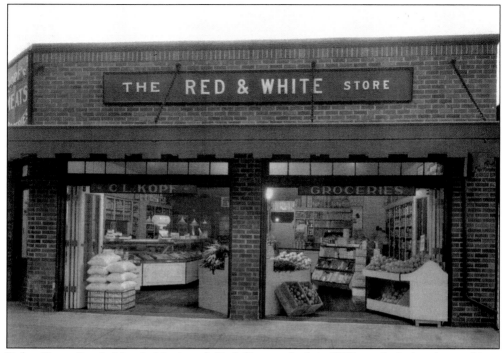

Before Totem Foods, Mrs. A. Messinger's Cash Grocery, built in 1905, supplied what the neighbors called the Twenty-sixth Street District. By 1931, the store, located at 3323 North Twenty-sixth Street, had changed to Strong's Grocery and was about to be demolished to allow for a new brick commercial building. George A. Richardson's Plumbing Company and the L. C. L. Baillis Grocery were the first to share the building. In 1935, Tacoma photographer Chapin Bowen recorded the then-named Red and White Store (above) with its open-market feature and the airy appearance of fresh produce. Chapin photographed the interior scene (below) the same day.

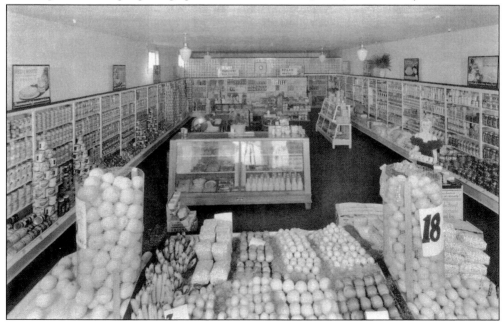

As elsewhere along the streetcar line, many homes survive from Tacoma's first building boom. Called "Post-Victorian comfortable houses" by one architectural historian, the two shown here are examples from the Twenty-sixth Street District. Above, at 3318 North Twenty-sixth Street, the Frank and Wilda Berg residence was built around 1895. The Frederick and Cora Weingarten residence (below), next door at 3324, was constructed about 1904. Frederick was a meat cutter by trade and, given the trend in Tacoma's North End, opened his house to boarders. Following Frederick's death in 1915, Emil and Phoebe Reitzel purchased the house and lived there until 1941. A streetcar lineman, Emil probably witnessed the transformation from the trolley to the motor bus.

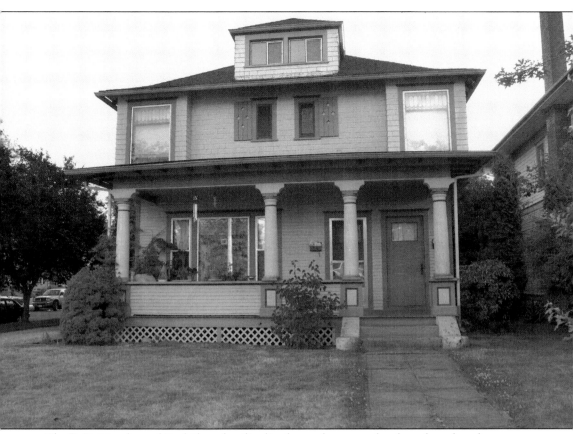

The E. D. Murphy and Paul Shaw families lived next door to each other when these houses were built during the first decade of the 20th century. Murphy both designed and built this residence at 2504 North Alder Street. "The combination of the Colonial and American types is very pleasing," noted the *Tacoma Daily Ledger* in 1907. Two years later, the *Ledger* described the Paul Shaw residence, located to the left in this view, as "very convenient and attractive" with its "furnace heat, sanitary plumbing, fireplace, and built-in bookcases in the living room." Paul Shaw served as secretary of the family-owned Tacoma Dental and Photo Supply Company.

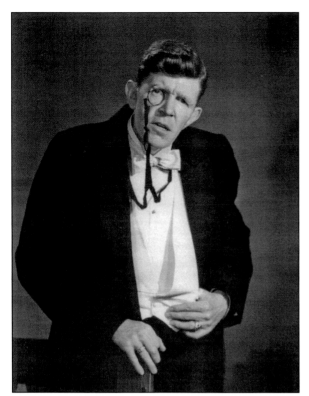

Robert Evans, who lived with wife, Alida, at 2408 North Alder Street, is another example of the past human diversity living along the streetcar line. Besides teaching English at Stadium High School, Evans was the drama coach and an actor in his own right. In 1954, a Richard Studio photographer captures him in one of his various poses.

The Van Rooy family lived at 2711 North Alder Street. Posing for a 1936 Christmas card portrait are, from left to right, (first row) son William, Marie, and daughter Mariana; (second row) daughter Betty Lou, Clemens W., and son Buster. Clemens Van Rooy was a public accountant and a retired major from the Washington National Guard. (Richards Studio.)

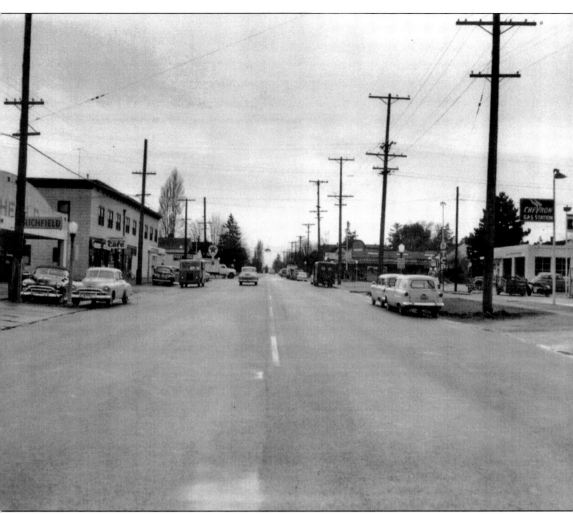

Once the streetcars passed through the Proctor District, the trolleys turned west onto North Thirty-fourth Street, and again a commercial center formed. In 1953, a Richards Studio photographer stood in the middle of North Proctor Street and pointed his camera north to capture the essence of the neighborhood. One of the interesting characteristics of this intersection is the number of service stations found within a rather small space following the automobile era. From left to right are a Richfield Gas Station, Harold's Café, a barbershop, and Sepich Refrigerator Service, with apartments on the second floor of the two-story building. A Texaco gas station and a candy store are visible in the distance. Chevron and Shell gas stations appear on the right, along with a brick building housing the Bay View Drugstore, Bay View Center Grocery, and Proctor Inn Confectionery. Safeway commissioned the view as a way to document congested parking.

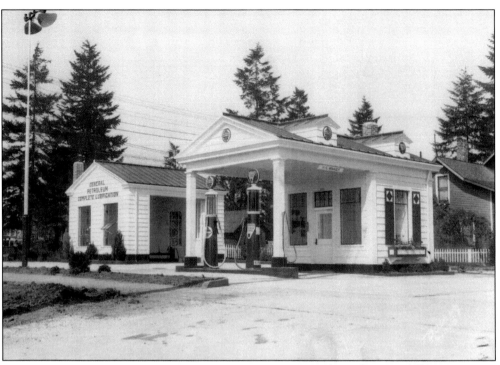

According to a 1931 advertisement, a motorist could get a "real grease job" for 50¢ at the Rowley Service Station, located at 3303 North Proctor Street. "Designed to give the motorist the latest in automobile service," the station could even clean upholstery with its "new up-to-date water-driven vacuum cleaner." (Photograph by Marvin Boland.)

By 1950, May's Shell Station stood north of Rowley's at 3319 North Proctor Street. Designed and built by Harry Berry, the business had a short life. The 7-Eleven that replaced the station marked another revolutionary change in grocery stores and might have been one of Tacoma's first. William Trueblood took this photograph on May 7, 1969, close to the time of its opening.

The North End Fruit and Produce Company, Berry Pharmacy, C. A. Tatum and Son Dry Goods, and Fred Fosdick's Confectionery all occupied the building at 3401–3407 North Proctor Street in 1927, when photographer Marvin Boland took this image. In 1968, Odell Wallace owned the Bay View Pharmacy, then in the building, and served as president of the Pierce County Pharmacy Association.

Robert and Harriet Bennatts—shown in their 1940 golden wedding anniversary portrait—and their children were prominent in the Thirty-fourth Street District for over a generation beginning around 1908, when the couple established a grocery at 3902 North Thirty-Fourth Street and lived in one of the upstairs apartments. Harriet, along with their son Cecil, died in March, and Robert died in October 1945.

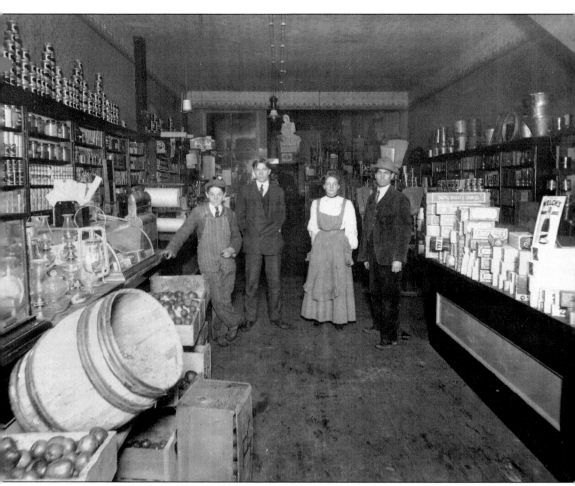

Mystery surrounds the origin of the building where Bennatts located his grocery. Some historians maintain that the Tacoma Railway and Power Company, which had purchased the streetcar line from Allen C. Mason, constructed the edifice in the late 1890s as a maintenance garage. Bennatts family members say that Robert S. built it for his grocery store in 1908. Whichever account proves correct, the building has been used in a multitude of ways. Besides Bennatts Grocery, from 1909 to 1913, the Whitworth postal station was situated there. In 1916, W. H. Froggatt's Motor Company occupied the building at 3312 North Proctor Street, making it one of the earliest automobile-related establishments along the streetcar line. Ford repairs were a specialty for Froggatt. While it is probable that this interior photograph of the Bennatts store comes from the family's Old Tacoma business, it does show members of the family in a setting they would know for the remainder of their lives.

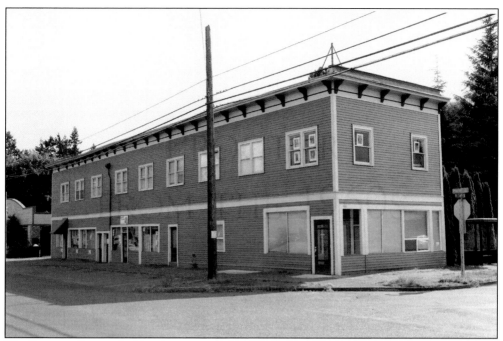

The Bennatts Grocery building has survived the test of time, as this 2007 Ron Karabaich photograph proves. Steven Ercegovic's Barber Shop, Thomas Brotherton's Shoe Repair, and the Proctor Meat Market would have been located in the North Proctor Street storefronts in the 1920s.

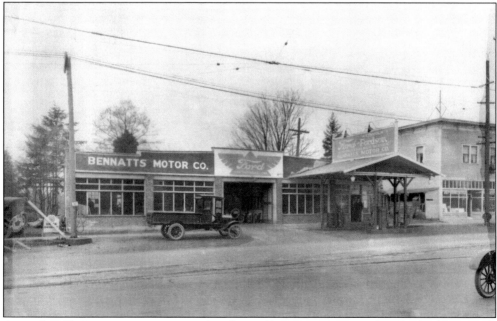

Around 1923, Bennatts commissioned architect E. J. Bresemann to design a building south of the grocery that would house the family's motor company. Located at 3310 North Proctor Street, the business included a Ford dealership along with a service station. By 1945, the year both Robert and Harriet died, the site had become a Richfield Service Station. (Photograph by Marvin Boland.)

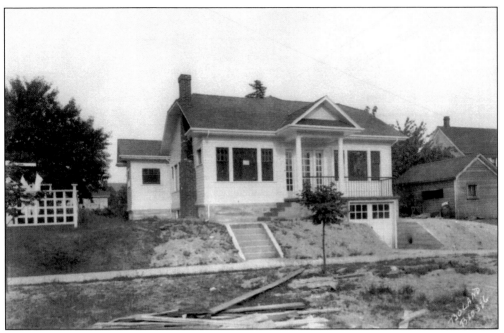

In 1924, O. H. Brasier built and sold this bungalow, located at 3413 North Proctor Street north of the commercial district. His *Tacoma Daily Ledger* advertisement had a sales price of $5,200, or $600 down and $45 per month. As a part of the year's sales campaign, photographer Marvin Boland took this view of the house.

Congressman Wesley Lloyd and his family lived at 3919 North Thirty-fourth Street, just west of Bennatts store. In 1932, Lloyd was the first to be elected to the newly created Sixth Congressional District, and the 53-year-old criminal lawyer had just begun a second term when he died of a heart attack in 1936. His well-attended funeral at Tacoma's First Baptist Church included over 150 floral displays. (Richards Studio.)

Eight

PROCTOR
FROM THE 1960S

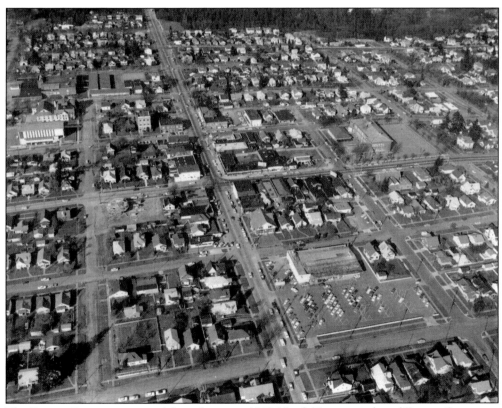

The Proctor District is pictured from the air in 1963. North Twenty-sixth and Proctor Streets are roughly in the center of the view. The new Mason Methodist Church and the telephone exchange building can be seen in the upper left. Proctor's first bank is under construction one block south. Washington School, but not Hoyt, and the southern edge of Puget Park appear in the upper right. What is most interesting is the Safeway, along with the surrounding area, seen in the lower right. For one thing, the store sits closer on North Twenty-fifth Street than it currently does. In addition, houses still stand on the lot, giving a hint regarding layout prior to the grocery store. Across North Proctor, homes fill the block where the Metropolitan Market is today. (Richards Studio.)

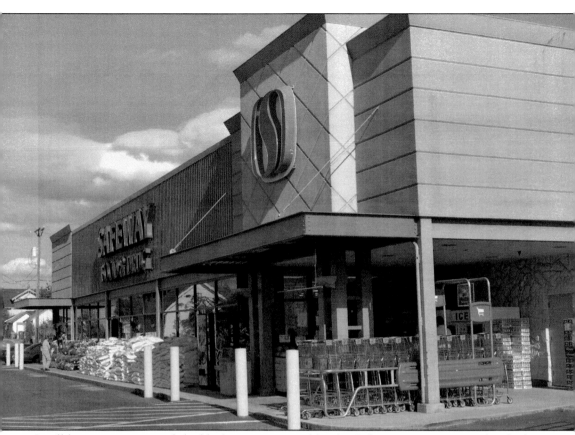

Small houses once covered the block now consumed by the Safeway grocery store. They had all been constructed during the early years of the 20th century as a part of the Proctor streetcar suburb. Safeway officials put some effort into deciding whether or not—and where—to build in the neighborhood. Several of the Richards Studio street views shown in this history were commissioned by the firm in the 1950s to document street congestion, most likely as a way to justify the large, off-street parking lot proposed for the development. The company's decision to build in the Proctor District signaled another change in markets, one that would replace the smaller mom-and-pop stores, along with the smaller franchises. According to the Pierce County assessor's files, the present Safeway grocery store was built in 1967. (Photograph by Ron Karabaich.)

M. L. Gamble constructed this house at 3819 North Twenty-fifth Street in 1922, and it remains one of the few that has survived the demolition for off-street parking. The structure stands just to the east of the fire station and directly across from Safeway. No doubt its adaptive reuse as a pet hospital has kept the house alive. (Photograph by Ron Karabaich.)

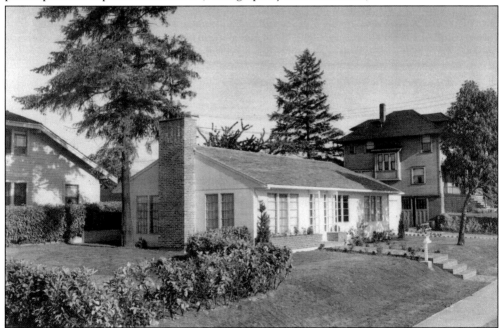

In 1946, the Tacoma Lumber Fabricating Company introduced what it considered a first-in-housing construction: the use of prefabricated materials, especially plywood. Located at 2810 North Proctor Street, the firm hired a Richards Studio photographer to record the entire building process, from raw ground to this completed view.

Automobile-related businesses have been present in the Proctor District ever since Americans began their love affair with the car. The last service station in the neighborhood survived into the 1970s on the northwest corner of North Twenty-sixth and Proctor Streets. Today the service garages are less visually obvious. Cooper's Collision Corner (above), located at 2709 North Adams Street, grew from a building constructed in 1913. Tiny's Garage (below) was built at 2612 North Adams Street in 1963. A greenhouse constructed for F. E. Beal in 1906 occupied the site prior to this time. (Photographs by Ron Karabaich.)

Except for Washington School, houses lined North Twenty-seventh Street before the streetscape gradually changed to commercial and public use. Some of the newer buildings represent those activities that truly make a neighborhood a neighborhood. The area post office was first housed in the Bennatts building at North Thirty-fourth and Proctor Streets and was then moved to the southwest corner of North Twenty-sixth and Adams Streets. In 1957, the postmaster general approved the construction of a new building (above) at 3801 North Twenty-seventh Street, one still operational today. Adjacent to the post office, in 1962 Freemasons built a temple (below) named to honor William P. Dougherty, who was one of Pierce County's first settlers and a Mason. (Photographs by Ron Karabaich.)

In 1923, Sanstrom and Company constructed a business block at 2615–2621 North Proctor Street. During the early years of the building's life, it was home to F. W. Thiel Confectionery, Zack Electric Goods, and Sanstrom Dry Goods, among others. In 1937, a Richards Studio photographer captured the interior of Edward Bright's Beauty Parlor, which shared one of the spaces at the time.

Cleo Stephenson was 17 when he arrived in Proctor in 1928 and found work at Whittier's Cleaners on North Twenty-seventh Street. When the Depression took its toll on the business, Cleo, then 19, was offered the business for past wages plus the total shop debt. Pictured here in 1932 is Cleo's sister Fern (left) and his wife, Viola, standing in front of his New Era Cleaners delivery van. (Leroy Hart photograph.)

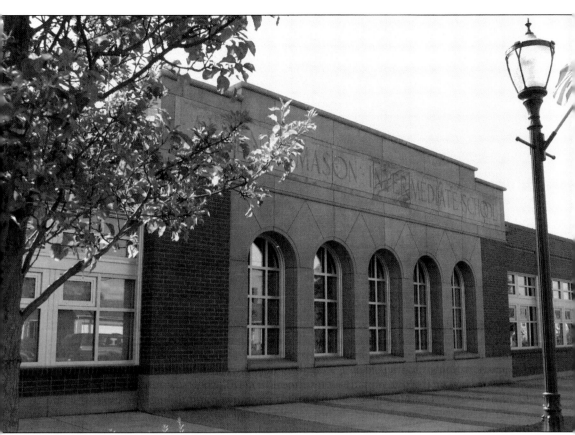

Mason School began to suffer growing pains almost from the moment it was built in 1926, and gradually additional outbuildings were placed on the site to accommodate the expanding student body. In 1952, a softball diamond and tennis courts were removed to construct the Proctor Annex. The 1963 aerial at the beginning of this chapter shows that even with expansion a few houses still remained on North Proctor. Further expansions in 1964 and 1980 ultimately covered the east part of the grounds with classroom buildings. In 1976, the school celebrated its 50th anniversary with future governor and former Mason student Dixie Lee Ray giving the guest lecture. When the school was ready to celebrate its 75th anniversary in 2001, the building was being prepped for demolition. All was not lost, however, when the new building opened for classes in 2003. A part of the older facade that was incorporated can be seen facing North Proctor Street. (Photograph by Ron Karabaich.)

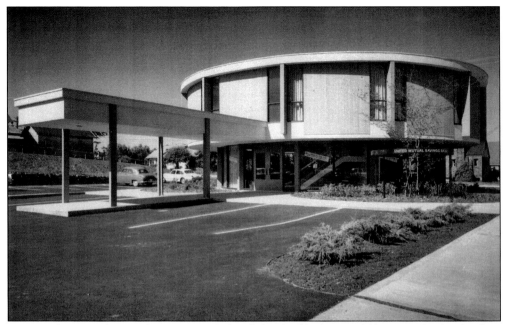

In 1963, the United Mutual Savings Bank decided to build what would become the first bank in the Proctor District. The architectural firm of Harris, Reed, and Wilson provided a unique, two-story circular design with the second story extending outward to create a round marquee. The Gardner Advertising Agency had a Richards Studio photographer record the building, located at 3916 North Twenty-sixth Street, just prior to its opening on June 29, 1963.

One year after the bank opening, builder O. H. Brasier completed Mason Manor Apartments at 3914 North Twenty-seventh Street. The 1960s building was another Proctor District first: the apartment house. While up to this time rental housing had been provided on the upper stories of retail buildings, the Manor introduced the possibility that multiple-family dwellings could become a part of the neighborhood. (Photograph by William Trueblood.)

Despite all that has been conveyed in this book, the available records are silent—for right now, at least—about the histories of many buildings that are a viable part of today's streetscape. For example, the structure on North Twenty-seventh Street that presently houses a karate school and a barbershop bears an unknown past. The two buildings at 2514 and 2522 North Proctor Street are other examples. The Rudolph R. Udovich Variety Store, shown above, was constructed around 1938, but little is known about the proprietor or the store. The building below is even more intriguing because Sanborn Insurance maps show something on the corner as early as 1912. This may or may not be the original structure. (Photographs by Ron Karabaich.)

Public art in the city's neighborhoods became a priority as the 20th century came to an end. Proctor District business owners took advantage of the opportunity by creating what would become a city first. Conceived by artist Paul Michaels, the project entailed embedding bronze markers in the sidewalks along North Proctor Street. Among those placed during the 1997 renovation were the two shown here. The above artist sketch is for Hachiro Takashima, who had a fruit stall in the neighborhood prior to World War II. Perkins Cycle Service appears below. Other markers depict the J. W. Faulkner Drugstore, the Washburn Grocery, the North End Tavern, and the Land and Dennison Hardware store. (Paul Michaels.)

In the country's cities, public art has taken many forms, including these salmon sculptures that one day appeared in the Proctor District. The concept is not unique to this neighborhood, of course. Various creative productions of sculptures have graced many areas of the United States. In Redding, California, for example, the well-dressed tourist graced city streets. In Seattle's University Village, decorative pigs once lined the walkways. A Dalmatian salmon has been installed at Engine Company No. 13 near the intersection of North Proctor and Twenty-fifth Streets. A second, glass-encrusted one sits two blocks north next to the Proctor Clock. (Photographs by Ron Karabaich.)

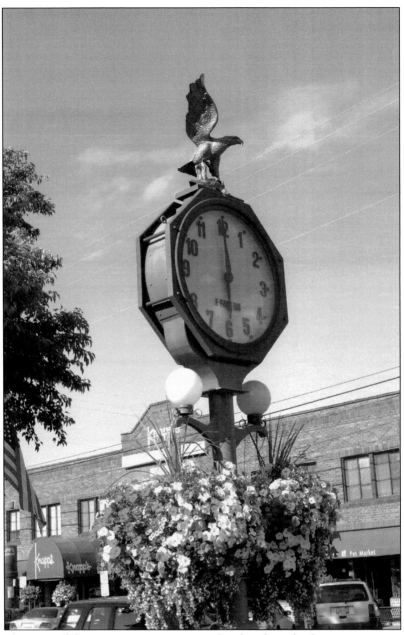

Knowing the time of day was not important until railroads and urban streetcars established schedules that riders were expected to meet. Street clocks were not initially public art, therefore, but a crucial way to tell time in the early days when most people did not own their own timepiece. City businessmen of the past also saw the advertising potential of a street clock; many clock faces on urban streetscapes bear the name of a particular firm. The Proctor District did not have a clock during the developing years of its history. Then, toward the end of the 20th century, local business owners viewed the presence of such a structure as a fine addition to the renovated North Proctor Street. Tacoma clock maker Edward F. "Doc" Farrens designed and installed the Proctor Clock shortly before his death in 2001. In this 2007 Ron Karabaich photograph, one of the neighborhoods landmarks—Knapps Restaurant—serves as a backdrop for the magnificent timepiece.

It is still possible to wander through the Proctor commercial district and get a feel for the past, as shown in this view of the south side of North Twenty-sixth Street between Proctor and Adams Streets. These storefronts display facades that have architecturally evolved from the earliest years of the 20th century to the current day. Each is an expression of the perceptions that past and present merchants have had regarding how their business fits into the overall economic vitality of the neighborhood. Today there are almost 100 such places of commerce, and even though the center of the district has changed its appearance over time, businesses still reflect the original neighborhood concept. The idea began when Allen C. Mason's first streetcar rolled around the corner of North Twenty-sixth. More than 100 years later, the Proctor District and surrounding neighborhood not only survives but thrives. (Photograph by Ron Karabaich.)

DISCOVER THOUSANDS OF LOCAL HISTORY BOOKS
FEATURING MILLIONS OF VINTAGE IMAGES

Arcadia Publishing, the leading local history publisher in the United States, is committed to making history accessible and meaningful through publishing books that celebrate and preserve the heritage of America's people and places.

Find more books like this at
www.arcadiapublishing.com

Search for your hometown history, your old stomping grounds, and even your favorite sports team.

Consistent with our mission to preserve history on a local level, this book was printed in South Carolina on American-made paper and manufactured entirely in the United States. Products carrying the accredited Forest Stewardship Council (FSC) label are printed on 100 percent FSC-certified paper.

MADE IN THE
USA